"Louis Markos not only po
uncanny ability to put cor
that is accessible to everyone. Such a gift is invaluable to the writing of a
student's guide to literature. Markos takes his readers through the principles
and ages of literature on a tour of discovery that is also a tour de force. The
wise and prudent student will read it avidly and then keep it near at hand as
a constant companion and guide—a literary friend upon whom the student
can always rely."

Joseph Pearce, Writer in Residence and Associate Professor of
Literature, Ave Maria University; author, *Through Shakespeare's Eyes*
and *Literary Converts*

"Louis Markos has produced an insightful digest of the most crucially impor-
tant issues confronting the serious student of literature. All the tools for study
are here, as well as an analytic account of literary commentary from Plato
on up to the present day. Written from a frankly Christian point of view, the
study reveals how essentially religious—until fairly recently—the Western lit-
erary tradition has been. Not only students will benefit from this learned and
perceptive overview, but mature scholars of the discipline will also find this
book a helpful and clarifying aid."

Louise Cowan, Professor of Literature, University of Dallas;
author, *The Epic Cosmos*

LITERATURE

RECLAIMING THE
CHRISTIAN INTELLECTUAL TRADITION

David S. Dockery, series editor

CONSULTING EDITORS

Hunter Baker
Timothy George
Niel Nielson
Philip G. Ryken
Michael J. Wilkins
John D. Woodbridge

OTHER RCIT VOLUMES

The Great Tradition of Christian Thinking, David S. Dockery and
 Timothy George
The Liberal Arts, Gene C. Fant Jr.
Political Thought, Hunter Baker
Philosophy, David K. Naugle

LITERATURE
A STUDENT'S GUIDE

Louis Markos

WHEATON, ILLINOIS

Literature: A Student's Guide

Copyright © 2012 by Louis A. Markos

Published by Crossway
 1300 Crescent Street
 Wheaton, Illinois 60187

Cover design: Jon McGrath, Simplicated Studio

First printing 2012

Printed in the United States of America

Trade paperback ISBN: 978-1-4335-3143-9
PDF ISBN: 978-1-4335-3144-6
Mobipocket ISBN: 978-1-4335-3146-0
ePub ISBN: 978-1-4335-3145-3

Library of Congress Cataloging-in-Publication Data

Literature : a student's guide / Louis Markos.
 p. cm.—(Reclaiming the Christian intellectual tradition)
 Includes index.
 ISBN 978-1-4335-3143-9 (tp)
 1. Literature. I. Title.
PN45.M3818 2012
809—dc23 2012001477

Crossway is a publishing ministry of Good News Publishers.

VP		21	20	19	18	17	16	15	14	13	12		
14	13	12	11	10	9	8	7	6	5	4	3	2	1

To
My two finest English majors
whose love for literature is only matched by their
passion for integrating their faith in
Christ with their literary studies:
Jennifer Harger
Jennifer Barton

And to four life-long learners
who have committed themselves to that same
wondrous integration:
Carol Drollinger
Sue Wendling
Bill Lederer
Steve Rummelsburg

CONTENTS

SERIES PREFACE

Reclaiming the Christian Intellectual Tradition

The *Reclaiming the Christian Intellectual Tradition* series is designed to provide an overview of the distinctive way the church has read the Bible, formulated doctrine, provided education, and engaged the culture. The contributors to this series all agree that personal faith and genuine Christian piety are essential for the life of Christ followers and for the church. These contributors also believe that helping others recognize the importance of serious thinking about God, Scripture, and the world needs a renewed emphasis at this time in order that the truth claims of the Christian faith can be passed along from one generation to the next. The study guides in this series will enable us to see afresh how the Christian faith shapes how we live, how we think, how we write books, how we govern society, and how we relate to one another in our churches and social structures. The richness of the Christian intellectual tradition provides guidance for the complex challenges that believers face in this world.

This series is particularly designed for Christian students and others associated with college and university campuses, including faculty, staff, trustees, and other various constituents. The contributors to the series will explore how the Bible has been interpreted in the history of the church, as well as how theology has been formulated. They will ask: How does the Christian faith influence our understanding of culture, literature, philosophy, government, beauty, art, or work? How does the Christian intellectual tradition help us understand truth? How does the Christian intellectual tradition shape our approach to education? We believe that this series is not only timely but that it meets an important need, because the secular culture in which we now find ourselves is, at

best, indifferent to the Christian faith, and the Christian world—at least in its more popular forms—tends to be confused about the beliefs, heritage, and tradition associated with the Christian faith.

At the heart of this work is the challenge to prepare a generation of Christians to think Christianly, to engage the academy and the culture, and to serve church and society. We believe that both the breadth and the depth of the Christian intellectual tradition need to be reclaimed, revitalized, renewed, and revived for us to carry forward this work. These study guides will seek to provide a framework to help introduce students to the great tradition of Christian thinking, seeking to highlight its importance for understanding the world, its significance for serving both church and society, and its application for Christian thinking and learning. The series is a starting point for exploring important ideas and issues such as truth, meaning, beauty, and justice.

We trust that the series will help introduce readers to the apostles, church fathers, Reformers, philosophers, theologians, and historians, and to a wide variety of other significant thinkers. In addition to well-known leaders such as Clement, Origen, Augustine, Thomas Aquinas, Martin Luther, and Jonathan Edwards, readers will be pointed to William Wilberforce, G. K. Chesterton, T. S. Eliot, Dorothy Sayers, C. S. Lewis, Johann Sebastian Bach, Isaac Newton, Johan Kepler, George Washington Carver, Elizabeth Fox-Genovese, Michael Polanyi, Henry Luke Orombi, and many others. In doing so, we hope to introduce those who throughout history have demonstrated that it is indeed possible to be serious about the life of the mind while simultaneously being deeply committed Christians. These efforts to strengthen serious Christian thinking and scholarship will not be limited to the study of theology, scriptural interpretation, or philosophy, even though these areas provide the framework for understanding the Christian faith for all other areas of exploration. In order for us to reclaim and advance the Christian intellectual tradition, we must have some understanding of the tradition itself.

The volumes in this series will seek to explore this tradition and its application for our twenty-first-century world. Each volume contains a glossary, study questions, and a list of resources for further study, which we trust will provide helpful guidance for our readers.

I am deeply grateful to the series editorial committee: Timothy George, John Woodbridge, Michael Wilkins, Niel Nielson, Philip Ryken, and Hunter Baker. Each of these colleagues joins me in thanking our various contributors for their fine work. We all express our appreciation to Justin Taylor, Jill Carter, Allan Fisher, Lane Dennis, and the Crossway team for their enthusiastic support for the project. We offer the project with the hope that students will be helped, faculty and Christian leaders will be encouraged, institutions will be strengthened, churches will be built up, and, ultimately, that God will be glorified.

Soli Deo Gloria
Series Editor

INTRODUCTION

Why Literature Matters

I mean to shoot straight in this book, and I will therefore begin—rather than end—by addressing the million-dollar question: What does studying literature have to do with real life? That's a question, almost always asked rhetorically, that many biology, engineering, and business majors like to tease English majors with. And yet, ironically, I have found that the people who are best able to answer the question are not the English majors themselves but doctors, engineers, and businessmen in the fifth or sixth decade of their lives.

No need to find an eager sophomore devouring a Shakespeare play on the quadrangle. Just ask a successful and seasoned surgeon or chemist or investment banker, and he will tell you how vital the life of the mind is. He will tell you that to be a full and balanced human being one needs to struggle with issues, ideas, and images that lie outside the specialized boundaries of one's chosen profession. True, one can achieve this balance in part by wrestling with art, music, history, philosophy, religion, and political science, but there is something about literature that personalizes and dramatizes the wrestling—that beckons the reader to enter into the arena.

It is a good thing to study the history, the cathedrals, and the scholasticism of the High Middle Ages, but it is a better thing to read the "General Prologue" to Chaucer's *Canterbury Tales*. To do the latter is to meet, to dialogue, to interact with late fourteenth-century England in all its glory, strangeness, and diversity. Once we have done so, we can no longer hold the men and women who lived in that time and place at arm's length. They are now members of

our community, old friends and sparring partners with whom we have something very much like a relationship.

I have devoted many years to studying the archeology of Mycenaean Greece, the political structures of Golden Age Athens, and the history of the Roman Republic and Empire, but I *know* the people of those bygone eras because I have immersed myself in the epics of Homer, the tragedies of Aeschylus, Sophocles, and Euripides, and the poetry of Virgil and Ovid. And the same holds true for the medieval Florentines of Dante, the Elizabethan Englanders of Shakespeare, and the Victorian Londoners of Charles Dickens. Literature holds up a mirror to life, and, in that mirror, it captures—or, better, holds in suspension—the subtle weave of beliefs and actions and passions that make us human.

But there is more! And that more reveals the true mystery behind great literature. The masterpieces that make up the Western literary canon present us, *simultaneously*, with the specific and the general, concrete details and universal themes, particular people living in a particular place and time, and transcendent character types that all readers at all times recognize immediately. They are, to paraphrase a line originally used of Shakespeare, not only of an age but for all time.

The orthodox believer who accepts the authority of Scripture will learn as much as he can about first-century Palestine, for the more he knows about the culture in which the early church was born, the more he will understand and profit from the letters of St. Paul. But he will not therefore reduce the epistles to mere products of Paul's socioeconomic milieu. As one of the inspired authors of the New Testament, Paul was more than a gifted Pharisee: he was one of God's chosen vessels through which revealed, eternal truths found their way into our fallen, time-and-space-bound world. Paul's letters hold in tension truths that partake of a local, provincial color while yet embodying transcendent, permanent Meaning.

In an analogous, rather than identical, way, great authors

from Homer to Virgil to Dante to Shakespeare reach, through the almost mystical power of their art, transcendent truths of permanent value. Though not inspired in the same direct way as Paul, Moses, and the other authors of the biblical canon, the authors of the literary canon—those to whom we ascribe the exalted title of "genius"—seem to have gained access to a fount of inspiration that, though not divine, is nevertheless supernatural. Even today, we speak of the great poets as being inspired by the Muse, or as having drunk from the Pierian Spring of the Muses. We recognize that they are tapping a source that lies somewhere beyond the narrow confines of their historical moment, and though we do not read their poems as prophecies, we treat them as prophetic in some way. And we are, I believe, right to do so.

I have always found it terribly ironic that people in the natural and social sciences will frequently claim that what they teach is more *true* than what literature teaches. I have often wondered how such people define the word *true*. Certainly one of the most essential qualities of truth is that it lasts, that it does not change radically from age to age and generation to generation, that it persists, endures, abides—which is precisely what does *not* happen in the sciences. Every fifty years—today it is more like every twenty—scientists reject the old paradigm in favor of a new one. The social sciences change even more rapidly, with one pedagogy giving way in quick succession to three others, and with psychology and sociology defining and redefining family, gender, and sexuality with dizzying speed. And when the paradigm shifts in these disciplines, those who still cling to the previous one are often dismissed as old-fashioned and backward. Of course, most of these old-fashioned scholars treated the "true believers" in the paradigm before *them* as equally primitive and backward, so perhaps there is justice (if not truth) in the whole cyclical game.

Contrast all this with the *Iliad* or *Oedipus* or *Aeneid* or *Inferno* or *Hamlet*. These works are as true today as they were when they

were written. Indeed, our age stands just as close to, and just as far away from, these works as did the contemporaries of Homer, Sophocles, Virgil, Dante, and Shakespeare. Granted, the theories of the radical literary critics—most of whom are social scientists in humanistic clothing—do not share in the permanence of the classic works that they have spent the last half century deconstructing. Modernist and postmodernist readings of the Great Books have veered back and forth in an almost maddening dance, but the works themselves continue to delight, to instruct, to mean.

HUMANIZING TECHNOLOGY

"Very well," answers the modern reader, "I will concede that the classic works of literature have endured for quite some time now, but what does that matter to someone living in the twenty-first century? We live in a new age of technology and specialization that has rendered the old age of literature obsolete." Though not often stated so directly, the criticism is a ubiquitous one that must be addressed.

Over the last several decades, a number of factors have worked together to push the study of great literature to the margins. The ever-growing, all-consuming presence of Internet and digital systems, not to mention the ever-expanding emphasis on visual media, has disrupted the dominance of printed (and *carefully composed*) material as our main vehicle of communication. The amassing of endless databases has privileged the skills of reason and analysis over those of imagination and synthesis. The ever-widening demand for a technically specialized workforce has increased the reputation of vocational learning at the expense of traditional liberal arts universities that offer a core curriculum grounded in the humanities in general and literature in particular. Perhaps most troubling of all, the persistent focus on present gratification and future progress has tended to cut us off from our past, from our traditions, from those deep roots that extend back

through the greatest works of the greatest minds. And these forces are often just as strong *within* the church as they are outside of it. In the face of such overwhelming forces, sincerity loses its human face, truth becomes diluted into efficiency, and design becomes but an impersonal, mechanical facsimile of that grander cosmic order celebrated by Dante, Shakespeare, and Milton.

Given such a state of affairs, the burden falls on the teachers and students of the literary canon to maintain a dialogue with the custodians of these great technological forces and to offer ourselves as midwives in a new and glorious birth through which even technology can become humanized and function as a friend to man's endless search for self-growth and awareness. Indeed, at the very start of the Industrial Revolution, Romantic poet William Wordsworth, in his "Preface to *Lyrical Ballads*" (1800), prophesied: "If the time should ever come when what is now called science . . . shall be ready to put on, as it were, a form of flesh and blood, the Poet will lend his divine spirit to aid the transfiguration, and will welcome the Being thus produced, as a dear and genuine inmate of the household of man." Literature need not, and should not, reject scientific and technological progress out of hand. Such great poets as Donne, Pope, and Tennyson were strongly conversant in the scientific advances of their day and wrestled with those advances in their poetry—and by wrestling, humanized them.

A generation after Wordsworth, a more extreme Romantic poet named Percy Bysshe Shelley went even further in asserting the power of poetry to humanize the natural and social sciences. In his "Defense of Poetry," Shelley argues vigorously for the central role of poetry and creative thought in an age of progress. "We have," he writes, "more scientific and economical knowledge than can be accommodated to the just distribution of the produce which it multiplies . . . our calculations have outrun conception; we have eaten more than we can digest." What we need now, he contends, is a power, a force

that can synthesize this sea of discrete facts into something tangible, something knowable. The poetic faculty, he argues,

> engenders in the mind a desire to reproduce and arrange [this sea of facts] according to a certain rhythm and order which may be called the beautiful and the good. The cultivation of poetry is never more to be desired than at periods when, from an excess of the selfish and calculating principle, the accumulation of the materials of external life exceed the quantity of the power of assimilating them to the internal laws of human nature.

I suggested earlier that without literature we cannot fully appreciate or understand the past. Shelley here goes further to suggest that without literature we cannot understand the present or the future. Literature, especially poetry, has the power—and the *anointing*, I would add—to explain ourselves to ourselves. That need is not vitiated by the recent and unprecedented advances in science and technology; to the contrary, it is increased. The twin growth of digital technologies (not only the Internet, but cell phones as well) and of specialization (not only in the natural and social sciences, but in the arts and humanities as well) has left us with an amorphous glut of information. We cannot live in such a vast sea of discrete, unassimilated, often anti-humanistic facts. We must make sense of the facts, must synthesize them somehow with what our race has learned about God, man, and the universe. Aside from the Bible itself—which is, in any case, composed of over a dozen different literary genres, especially poetry—literature is one of our best tools and guides for achieving this grand and humanizing synthesis.

THINKING LIKE A POET

It will be my goal in the chapters that follow to provide a foundation for understanding and appreciating poetry: and let me make it clear at the outset that my focus will be almost exclusively on

poetry. Until quite recently, poetry has been privileged above prose as a higher, and even more spiritual, form of literary writing, and most who have written in defense of literature—from Aristotle to Sidney to Shelley—have written in defense of poetry. Indeed, though I have titled this introduction "Why Literature Matters," you will note that my real thrust has been to argue that *poetry* matters.

So poetry it is, but if all I can do in this book is convince you that poetry matters, I will not be satisfied. I mean to inspire you to think *like* a poet, to view the world aesthetically rather than scientifically, imaginatively rather than rationally, intuitively rather than logically. That is not to say that I want you to abandon the head in favor of the heart or the intellect in favor of the emotions, but it is to say that I expect from you a willingness to embrace poetry on its own unique terms—terms that call for *both* spontaneity and precision, inspiration and craftsmanship. Accordingly, I will begin with two "brass tacks" chapters on prosody (rhythm and rhyme) and figurative language. Rather than provide an encyclopedic overview of these topics, I shall focus on defining key terms and concepts and describing how and why poets work within fixed metrical schemes and in accordance with a metaphorical view of the world.

Having covered the building blocks of poetry, I will move on to the heart and soul of my book: a lengthy and detailed survey of Europe's major aesthetic ages and the particular authors, genres, themes, and approaches that dominated those ages: the Classical, the Medieval, the Renaissance, the Enlightenment, the Romantic, and the Victorian and early modern. This chapter will be followed in turn by a final, theory-based chapter in which I will survey the major texts and phases of literary criticism and show how each phase sought, in its own way, to defend poetry from its Platonic and/or Christian detractors. I will conclude by briefly critiquing three postmodern schools of theory that have, I believe, drawn students not toward great literature but away from it.

I also hope, over the course of this book, to convince Christian students and teachers that they, far from being suspicious of poetry or considering it frivolous, should be in the front lines of poetry's defenders. It is those who believe in the Bible as the inspired Word of God and who believe that Jesus himself is the incarnate Word of God who are best poised to champion the truth-giving potential of all poetry, whether sacred or secular.

ACKNOWLEDGMENTS

I would like to express my special thanks to Houston Baptist University for awarding me the Robert H. Ray Chair in humanities and the title of scholar-in-residence. The extra time provided me by the chair and the title has made it possible for me to complete this book. I would also like to thank Houston Baptist University for inviting me to teach the freshman classical Christian curriculum (Homer to Dante) for our new Honors College, a position that has allowed me to immerse myself and my students in the glories of the Classical and early Christian Age.

 1

RHYTHM AND RHYME

Until the twentieth century, nearly every poem written in English was built upon the framework of a set rhythmical scheme. Though many poems were written that did not rhyme, very few were written that did not adhere to a fixed pattern of stresses. This recurring metrical pattern formed the blueprint for traditional poetry: a blueprint that was as rigid as it was supple, as systematic as it was inexhaustibly flexible. In the best poetry, this blueprint combined the logical order of the mathematical proof with the gentle undulations of the lullaby.

Though many link traditional meter to the counting of syllables, a true and proper understanding of meter rests not on counting syllables but on hearing stresses (or accents). Every word we write or speak has at least one stress. In a one-syllable word, the stress falls on the one syllable. But in 99 percent of two-syllable words, and in the vast majority of three-syllable words, only one syllable will carry a stress. In the words *today*, *because*, and *intervene*, the stress falls on the final syllable; in the words *joyous*, *season*, and *yesterday*, the stress falls on the first syllable. There are two ways to write this out. Either we can place an accent mark (′) over the stressed syllable and a line (‾ or ˘) over the unstressed syllable, or we can simply write the stressed syllable in ALL CAPS. In this book, I will adapt the second method. The six words mentioned above would be written thus: to-DAY, be-CAUSE, in-ter-VENE, JOY-ous, SEA-son, YES-ter-day.

Though few people realize it, when we say that a person from another state or country speaks with an accent, we often mean,

literally, that he puts his accent on an unexpected syllable. Thus, whereas the standard pronunciation of the words *cement* and *insurance* are ce-MENT and in-SUR-ance, most people in my home city of Houston shift the accent to the left and pronounce these words as CE [SEA]-ment and IN-sur-ance. Interestingly, when the accent is changed, it often forces some of the vowels to change as well. Thus, in the first example, the first "e" changes its sound quite dramatically, while, in the second example, the change in the "u" sound is a bit more subtle.

Here are three more examples: (1) Americans watch AD-ver-tise-ments on TV, while the British watch ad-VER-tise-ments (note that the "i" changes its sound); (2) if a secretary suffers ha-RASS-ment on the job, her lawyer will sue the boss for HAR-ass-ment (note that the first "a" changes its sound); (3) students refer to the author of *The City of God* as AU-gus-tine, while their theology professors call him Au-GUS-tine (note that the "i" changes its sound).

IDENTIFYING POETIC FEET

Only once we have learned to distinguish the stresses in the words we use can we begin to understand poetic rhythm (or meter). In prose writing and in normal speech, the stresses come at us helter-skelter, in no set pattern; in traditional poetry, however, the stresses fall into a series of recurring metrical units known as **feet**. A poetic foot (pl.: feet) is a two- or three-syllable unit with one stressed syllable (S) and one or two unstressed syllables (U). The four basic feet on which traditional English poetry is built are as follows:

iamb (adj.: iambic)	U/S	to-DAY
trochee (adj.: trochaic)	S/U	JOY-ous
anapest (adj.: anapestic)	U/U/S	in-ter-VENE
dactyl (adj.: dactylic)	S/U/U	YES-ter-day

Note that there is no foot that looks like this: U/S/U. There is,

however, one type of foot that breaks the one-stress-per-foot rule. It is called a **spondee** (adj.: spondaic), and it is composed of two stresses (S/S), as in the word *football* (FOOT-BALL). Though I have used one-word examples to illustrate each poetic foot, the foot can be composed of more than one word, or it can be composed of parts of one or more words. The phrase "at the FAIR" is an anapest; the first two syllables of "be-COM-ing" form an iamb.

If we want to determine the rhythm/meter of a poem, we do not count the number of syllables in each line but the number of feet; of course, in counting the number of feet, we are also counting the number of stresses (since each foot has one stress). Each line of the poem will consist of one or more feet. If the line has only one foot it is referred to as a **monometer** line. Here are the words to designate lines that are composed of more than one foot:

2 feet	dimeter
3 feet	trimeter
4 feet	tetrameter
5 feet	pentameter
6 feet	hexameter
7 feet	heptameter
8 feet	octameter

Once we know the names of each foot (in its adjectival form) and the names used to designate the number of feet in the line, we can come up with formal names to describe each line of poetry. If the line is composed of three iambs, it is called an **iambic trimeter** line. Here are some other combinations:

4 trochees	trochaic tetrameter
5 anapests	anapestic pentameter
6 dactyls	dactylic hexameter

SCANNING LINES

If we are reading a traditional poem, and we would like to determine its meter, we must *scan* the poem (noun: scansion). We do this in the form of a three-step process. First, we must figure out where the stresses fall in the line. Consider this line from Alexander Pope: "Eternal sunshine of the spotless mind!" Here are the syllables where the stresses fall:

e-TER-nal SUN-shine OF the SPOT-less MIND

Once we have written in the stresses, we need to study the line carefully and see if those stresses fall into a pattern. In this case, there is a clear iambic pattern of alternating unstresses and stresses. We then complete the scansion by putting a slash (/) between each foot:

e-TER / nal SUN / shine OF / the SPOT / less MIND

If we count up the number of iambs, we will find that we have here a line of iambic pentameter: not surprising, since iambic pentameter is the most common poetic line in English. Here are some other examples of scanned lines:

Be-CAUSE / i WOULD / not STOP / for DEATH
 (iambic tetrameter)
HAIL to / THEE blithe / SPIR-it (trochaic trimeter)
On the EIGH / teenth of A / pril in SE / ven-ty FIVE
 (anapestic tetrameter)
CAN-non to / RIGHT of them (dactylic dimeter)

Because of the important role that a set rhythm plays in traditional poetry, poets will sometimes "bend" their words in order to make them fit the meter. Consider these two lines from Martin Luther's great hymn, "A Mighty Fortress Is Our God":

His CRAFT / and POW'R / are GREAT
And ARMED / with CRU / el HATE

Both of these lines are written in iambic trimeter; however, to make the meter work properly, Luther (or, more accurately, his translator) was forced to adapt a word in each line. In the first line, the two-syllable word "power" is condensed down to the one-syllable "pow'r" (by a process known as **elision**). In the second line, the one-syllable word "cruel" is stretched out into the two-syllable "cru-el." Anyone who sings hymns will have noticed how often hymns force us to pronounce the two-syllable word *heaven* as if it were one syllable (heav'n): to make it worse, we are often expected, somewhat unnaturally, to rhyme the one-syllable "heav'n" with "giv'n." Lovers of Shakespeare will no doubt have noticed how often the bard expects us to pronounce a past-tense verb such as *loved* as if it were two syllables: lov-ed. If the poet is nice, he will mark his elisions by using an apostrophe ("heav'n") and his extensions by using an accent mark ("lovéd"), but poets do not always do that, and the reader is often left to figure out when a word needs to be elided or extended.

RECOGNIZING SUBSTITUTIONS

Although nearly every line of poetry written before the modern period can be identified by its number of feet, poets rarely repeat a poetic line over and over again in the exact same way. While maintaining a set pattern of, say, iambic pentameter, poets will vary their meter through the use of poetic **substitutions**. At any point in the line, poets may substitute one foot for another. In this example from *Richard III*, Shakespeare varies his iambic pentameter line by substituting a trochee for the first iamb of the line:

NOW is / the WIN / ter OF / our DIS / con-TENT

The student who scans this line and notices that it begins with a trochee might at first be tempted to label the line "trochaic," but

he would be wrong to do so. A line is defined by its *dominant* foot, not by its initial foot. In the example above, the first foot is a trochee, but it is followed by four iambs. The line is therefore not trochaic but iambic with a trochaic substitution. Here are some other examples with accompanying explanations:

> she DWELT / a-MONG / the un-TROD / den WAYS
> (iambic tetrameter; an anapest has been substituted for the
> third iamb)
> a-WAY / in a MAN / ger no CRIB / for a BED
> (anapestic tetrameter; an iamb has been substituted for the
> first anapest)
> TEN-der-ly / TEN-der-ly / JE-sus is / CALL-ing
> (dactylic tetrameter; a trochee has been substituted for the
> fourth dactyl)
> By THIS / STILL HEARTH / a-MONG / these BAR / ren
> CRAGS
> (iambic pentameter; a spondee has been substituted for the
> second iamb)

Another variation that poets make in their lines to avoid monotony and to vary (without breaking) the set rhythm is to add an additional unstressed syllable to the end of the line. In the following example, the extra unstressed syllable is underlined:

> To BE / or NOT / to BE / that IS / the QUES-<u>tion</u>
> WHE-ther / 'tis NOB / ler IN / the MIND / to SUF-<u>fer</u>
> (note that in the second line a trochee has been substituted for
> the first iamb)
> We GA / ther to-GE / ther to ASK / the Lord's BLESS-<u>ing</u>
> (note that an iamb has been substituted for the first anapest)

This technique of adding an unstressed syllable to the end of the line is only used when the dominant foot is an iamb or an anapest, that is, in lines that end with a stress. When the dominant foot is a trochee or a dactyl, a different variation is used. Instead

of adding an additional unstressed syllable, the final unstressed syllable is dropped. In the following trochaic tetrameter line, the expected unstressed syllable at the end of the line is dropped, leaving a strong-sounding line that both begins and ends with a stress (I've underlined the missing syllable):

TY-ger / TY-ger / BUR-ning / BRIGHT ___

The technical term for this variation is a **truncation,** for the last (unstressed) syllable has been cut off (or truncated). Truncation can also be used on dactylic lines, though in some cases, the truncation is indistinguishable from a substitution:

HALF a league, / HALF a league, / HALF a league, / ON-ward ___

It would be proper to describe this line *either* as truncated dactylic tetrameter *or* as a dactylic tetrameter line in which a trochee has been substituted for the fourth dactyl. There are, however, cases where a dactylic line will have both of its final unstressed syllables dropped (a sort of double truncation); in this case, the line has clearly been truncated, for only a single stressed syllable remains to make up the foot. Consider these two lines from a well-known hymn; the first line has had its last syllable truncated, while the second line has been double truncated:

GREAT is thy / FAITH-ful-ness / O God my /FA-ther ___
THERE is no /SHA-dow of / TUR-ning with / THEE ___ ___

It must be added here that there are some literary critics who, when confronted with a line such as "Tyger! Tyger! burning bright," insist on referring to it as truncated iambic. They do so because they prefer to scan the line thus:

___ TY / ger TY / ger BURN / ing BRIGHT

I myself am *strongly* opposed to this practice, for it violates the integrity of the trochee. The rhythm and "feel" of "Tyger! Tyger! burning bright" is fully trochaic and must be distinguished from the very different rhythm and feel of the iamb. And it is important to make this distinction, for the use of truncation in trochaic and dactylic verse is quite common. Aside from allowing a poet to begin and end his line with a stress, truncation also allows him to make use of a masculine, rather than a feminine, rhyme.

A **masculine rhyme** is one that ends on a stress. In most cases, a masculine rhyme makes use of one-syllable words: gold/told, free/tree, sing/bring, brave/gave. It is possible, however, for one or both of the words in a masculine rhyme to have two or three syllables: LET/for-GET, BLEED/in-DEED, GREEN/in-ter-VENE. What makes it a masculine rhyme is that the stress falls firmly on the last syllable, giving the rhyme a strong, "masculine" feel. In a **feminine rhyme**, where the words *must* be at least two syllables long, the stress is followed by one or two unstressed syllables: FLY-ing/DY-ing, SING-ing/BRING-ing, a-DOR-a-ble/de-PLOR-a-ble. (Note that even in the feminine rhyme, the actual rhyme itself still falls on the stress; the syllables that follow the stress must be exactly the same in sound for the feminine rhyme to work properly.) Here, the feel is more light and flowing (more "feminine") than in the harder, sharper masculine rhyme.

Although poets who write in Italian, French, and Spanish— languages in which many words have the same endings—make heavy use of feminine rhymes, most English poets prefer to use masculine rhymes. English, with its strong monosyllabic Germanic roots, naturally gravitates toward masculine rhymes; indeed, when an unskilled (or even a skilled) English or American poet uses too many feminine rhymes, he risks making his poem sound frivolous and "sing-songy." (Byron's satirical *Don Juan*, the light operas of Gilbert and Sullivan, and comedy-driven Broadway musicals all make heavy use of feminine rhymes.) By

truncating his trochaic lines, the poet ensures that his lines will end on a stress—thus allowing him to use masculine rhymes. Consider the difference in feel and gravity between the following two pairs of lines (truncated trochaic tetrameter, followed by trochaic tetrameter):

> Nothing in my hand I bring, / Simply to the cross I cling
> Nothing in my hand I'm bringing / Simply to the cross I'm
> clinging

There is a firmness and nobility in the first pair of lines that is compromised in the second by the use of the less stately feminine rhyme, "bringing/clinging."

CATEGORIZING STANZAS

Thus far, I have considered individual lines of poetry in isolation. When we read actual poems, we encounter them not as individual lines but as members of a tightly knit group of lines known as a **stanza**. These stanzas are defined both by the meter of the lines that make them up and by the rhyme scheme that binds the lines together. Though it is possible to make use of a stanza that does not rhyme, in nearly all cases, the stanza will contain at least one pair of rhyming words. To designate the rhyme scheme of a stanza, we use the letters of the alphabet. If the four lines of a four-line stanza end with the words "may/sea/day/me," then the rhyme scheme would be written thus: *abab*. If the last four words were "may/day/sea/me," then the rhyme scheme would be *aabb*. If the last four words were "may/see/you/me," then the rhyme scheme would be *abcb*. Although the majority of rhymes are exact rhymes (feel/steal), poets often use rhymes that are not exact (known as **off rhymes** or **eye rhymes**): love/prove, bone/done, mind/thine, Lord/word, heaven/given.

Once a poet establishes a stanza form, he will repeat that stanza over and over again—though he will likely scatter metrical

substitutions throughout the poem. (In the case of formal hymns meant to be sung, there can be no substitutions since each stanza must fit the same tune; if there *is* a substitution, it will have to be repeated faithfully in each stanza so as not to disrupt the singing.) If the poet *does* decide to vary either the meter or the rhyme scheme of one or more of his stanzas, he will do it for a very specific reason, usually to call attention to that specific stanza or to a specific line within the stanza. Still, the general rule is that each stanza maintain the same meter and rhyme—a rule that is only violated on the large scale when the poet sets out to write a specific kind of poem known as an **ode**. In odes, both the ancient Greek odes of Pindar and more modern ones like Wordsworth's "Intimations Ode" or Coleridge's "Dejection: An Ode," each stanza varies in its meter, its rhyme scheme, and even its number of lines. Let us consider some common stanza forms.

Heroic couplets are formed of two iambic pentameter lines that rhyme *aa*. Alexander Pope, who lived and wrote during the Age of Reason, was the master of the heroic couplet, and he mined it for all its worth. Here is an example from his *Essay on Man*:

> Say FIRST / of GOD / a-BOVE / or MAN / be-LOW,
> What CAN / we REA / son BUT / from WHAT / we KNOW?

Though Romantic poets like William Wordsworth and Percy Shelley would occasionally write in heroic couplets, the form is strongly associated with the eighteenth-century Enlightenment. As used by Pope, the heroic couplet is always tightly organized with a strong stop at the end of each couplet, marked by a period, a semicolon, or a colon (only occasionally a comma). The couplets are further arranged in the form of a mathematical proof that moves logically, step-by-step, from proposition to proposition to conclusion. In the movement of Pope's heroic couplets, we can feel the balance, the order, and the rationality that his Age of Enlightenment prized so highly.

Ballad rhythm is a medieval form, but it was revived powerfully in the Romantic age by poets like Wordsworth and Coleridge. It is composed of four lines that rhyme either *abcb* or *abab*. Lines one and three are written in iambic tetrameter; lines two and four are written in iambic trimeter. Many hymns are written in ballad rhythm, the most famous being "Amazing Grace":

> a-MA / zing GRACE / how SWEET / the SOUND
> That SAVED / a WRETCH / like ME!
> i ONCE / was LOST / but NOW / am FOUND
> Was BLIND / but NOW / i SEE.

The form is also popular with writers of folk songs:

> Should AULD / a-CQUAIN / tance BE / for-GOT
> and NE / ver BROUGHT / to MIND?
> Should AULD / a-CQUAIN / tance BE / for-GOT
> and DAYS / of AULD / lang SYNE.

Because both of these songs are written in ballad rhythm, each song can be sung to the other's tune. Indeed, *any* song or poem that is written in ballad rhythm can be sung to the tune of "Amazing Grace" or "Auld Lang Syne."

Both of these examples use an *abab* rhyme scheme (mind/syne is an off rhyme); however, in most medieval romances, including Coleridge's modern version of a medieval romance, *The Rime of the Ancient Mariner*, the rhyme scheme is *abcb*. Here is a stanza from Coleridge's *Rime* (cold/emerald is another off rhyme):

> And NOW / there CAME / both MIST / and SNOW,
> And IT / grew WON / drous COLD:
> And ICE / mast HIGH, / came FLOAT / ing BY,
> As GREEN / as EM / e-RALD.

Although this stanza follows an *abcb* rhyme scheme, I hope the reader will note that there is another rhyme lurking in the stanza.

Notice that the words "high" and "by" in line three rhyme. This is called an **internal rhyme,** and it is used often in the first and/or third lines of a ballad rhythm stanza that rhymes *abcb*. There is really no shorthand way of indicating internal rhyme, unless we improvise and write *ab(cc)b*.

A slight variation of ballad rhythm can be found in this well-known Christmas carol that is sung to the haunting tune of "Greensleeves":

> What CHILD / is THIS, / who, LAID / to REST
> On MA / ry's LAP, / is SLEEP-*ing?*
> Whom AN / gels GREET / with AN / thems SWEET,
> While SHEP / herds WATCH / are KEEP-*ing?*

Here we still have the tetrameter/trimeter/tetrameter/trimeter alternation of ballad rhythm, but this time, lines two and four end with an extra unstressed syllable. This changes subtly the music of the stanza, partly by necessitating a feminine rhyme in lines two and four (sleeping/keeping). Note also that in this example the rhyme scheme is *abcb* but with an internal rhyme in line three (greet/sweet): *ab(cc)b*.

All **sonnets** are fourteen lines long and written in iambic pentameter; however, sonnets differ in their rhyme scheme. There are two major types of sonnets. The oldest is known as the **Petrarchan** or **Italian** sonnet, after a Florentine poet named Petrarch. It was followed a century later by the **Shakespearean** or **English** or **Elizabethan** sonnet, for its greatest practitioner was none other than the English Elizabethan Shakespeare.

The Petrarchan sonnet is made up of two unequal halves: an eight-line unit (called an **octave**) rhymed *abbaabba* followed by a six-line unit (called a **sestet**) whose rhyme scheme varies: *cdecde, cdcdcd, cddcee*. Somewhere near the beginning of line nine there will generally be a word (but, thus, therefore) that marks the transition from the octave to the sestet: this word (or short phrase) is

called the **turn**. The skilled Petrarchan sonneteer will make careful use of this two-part structure in composing his sonnet. He may use the octave to state a problem and then use the sestet to solve the problem. He may be general in the octave and specific or personal in the sestet. Yet again, he may use the octave to describe a historical event and then use the sestet to explore the meaning of that event.

The Shakespearean sonnet, in contrast, is divided into four parts: three four-line quatrains (*abab, cdcd, efef*) and a couplet (*gg*). In a typical Shakespearean sonnet, the poet will state a problem in the first quatrain, restate it in the second, restate it again in the third, and then solve it in the couplet. Though the rhyme scheme of the Shakespearean sonnet is far less demanding than that of the Petrarchan, it does impose a great challenge on the sonneteer: how to build up a question or problem or dilemma in twelve lines and then solve it in two. In the best Shakespearean sonnets, the reader will be surprised by the sting in the adder's tale—that is, a witty couplet that somehow manages to turn the previous three quatrains on their head!

> That time of year thou mayst in me behold
> When yellow leaves, or none, or few, do hang
> Upon those boughs which shake against the cold,
> Bare ruined choirs where late the sweet birds sang.
> In me thou see'st the twilight of such day
> As after sunset fadeth in the west,
> Which by-and-by black night doth take away,
> Death's second self that seals up all in rest.
> In me thou see'st the glowing of such fire
> That on the ashes of his youth doth lie,
> As the deathbed whereon it must expire,
> Consumed by that which it was nourished by,
> This thou perceiv'st, which makes thy love more strong,
> To love that well which thou must lose ere long.

Here, in "Sonnet 73," Shakespeare spends the first twelve lines of his poem detailing a problem that is causing him great pain and anxiety, namely, that he is getting older and he fears his beloved will cease to love him. With each succeeding quatrain, he speeds up the process of age and decay that he so fears. First he compares himself to the season of autumn, which lasts three months; then to the ending of a day, which lasts twenty-four hours; then to a dying fire, which lasts only a few short hours. When all seems dark and old, and hope has abandoned the despairing poet, he is saved by the intervention of the bold and unexpected couplet: not only does his fast-approaching mortality *not* repel his beloved; it actually *increases* her love for him.

Before moving on, "Sonnet 73" offers a good opportunity to explain an element of poetry that is the bane of English teachers. Whenever a student is asked to read aloud a poem like "Sonnet 73," his first impulse is to stop dead at the end of each line of poetry. Though it is understandable that readers are tempted to do so, they should not pause unless there is some kind of punctuation mark at the end of the line. If there is no punctuation mark at the end of the line (as there is not at the end of lines 1, 2, 5, and 9), then the reader should continue reading without pausing. When one line runs directly into the next line without any punctuation, it is referred to as an **enjambment**. Great poets will be careful in their use of enjambment, making sure to achieve just the right balance between enjambed and end-stopped lines.

The **Spenserian stanza**, brought to perfection in Spenser's *Faerie Queene*, is nine lines long and is rhymed *ababbcbcc*. Like the sonnet, the Spenserian stanza is written in iambic pentameter, but with one exception. Each stanza concludes with an iambic hexameter line, a line that poets and critics refer to as an **alexandrine**. In his *Essay on Criticism*, Pope makes fun of the alexandrine in this famous couplet:

a USE / less A / le-XAN /drine ENDS / the SONG,
that LIKE / a WOUN / ded SNAKE /DRAGS its / slow
 LENGTH / a LONG.

Notice that to extend even further the length of the alexandrine, Pope substitutes a trochee for the fourth foot of the alexandrine.

Rhyme royal, made famous in Chaucer's *Troilus and Criseyde,* is composed of seven iambic pentameter lines that rhyme *ababbcc.* In his poem "Resolution and Independence," Wordsworth uses rhyme royal but transforms the last line into an alexandrine.

Ottava rima, an Italian form that was used famously by Lord Byron in his satirical epic *Don Juan,* is composed of eight iambic pentameter lines that rhyme *abababcc.*

Terza rima, invented by Dante for his *Divine Comedy,* is composed of a connected series of three-line stanzas (tercets) that rhyme *aba, bcb, cdc, ded,* and so forth.

All of the stanza forms described above have been used again and again by succeeding generations of poets. Many poets, however, most notably John Donne; George Herbert; Percy Bysshe Shelley; and Alfred, Lord Tennyson, experimented with new stanza forms—a number of which they only used once. Here is one of my favorite "invented" stanza forms:

HAIL to / THEE blithe / SPIR-it!
 BIRD thou / NE-ver / WERT,
THAT from / HEAV'N or / NEAR it,
 POUR-est / THY full / HEART
In PRO / fuse STRAINS / of UN / pre-ME / di-TA / ted ART.

This audaciously unique stanza form, created by Shelley for his "To a Skylark," consists of five lines rhymed *ababb.* Lines 1 and 3 are trochaic trimeter, lines 2 and 4 are truncated trochaic trimeter, and line 5 is (unexpectedly) an alexandrine. Note that in order for lines 2 and 4 (written in trochees and thus ending with an unstressed syllable) to share a rhyme with line 5 (written in iambs

and thus ending with a stressed syllable), lines 2 and 4 *must* be truncated: only thus can they share a masculine rhyme with line 5 (wert/heart/art). Lines 1 and 3, in contrast, make use of a feminine rhyme (spirit/near it).

Though the majority of traditional poems written in English make use of stanza forms like those listed above, there is one form of English poetry that makes use of neither rhyme nor stanzas. I speak of **blank verse**, a poetic form that consists of an unbroken succession of unrhymed iambic pentameter lines. Shakespeare's great soliloquies, Milton's *Paradise Lost*, Wordsworth's *Prelude*, most of Browning's mature dramatic monologues, and Tennyson's *Idylls of the King* are all written in blank verse. Blank verse has both a sweeping and a meditative feel to it and makes heavy use of enjambment. It comes closer than any other form of poetry to capturing the twists and turns of human thought. Although Shakespeare's soliloquies and the individual books of *Paradise Lost* are written in one long block of poetry, in the shorter blank-verse poems of the Romantics (for example, Wordsworth's "Tintern Abbey." and Coleridge's "The Eolian Harp"), the poem is often broken up into sections called **verse paragraphs,** as if the poem were a poetic essay.

One of the major reasons that Milton chose blank verse for *Paradise Lost* was that he considered it to be the English equivalent of the **epic meter** of Homer and Virgil. The *Iliad*, the *Odyssey*, and the *Aeneid* are all written in a series of unrhymed truncated dactylic hexameter lines (the second unstressed syllable of the last dactyl is dropped). Interestingly, though the ancients allowed substitutions to the line, they allowed only one special type of substitution: anywhere along the hexameter line, the poet could substitute a spondee for one or more of the dactyls. Here is my own loose translation of lines one to four of the *Iliad*; lines one and four have no spondaic substitutions, but lines two and three have one and two substitutions, respectively:

SING to me / GOD-dess the / TER-ri-ble / WRATH of the /
 GOD-like a / CHIL-les,
FU-ri-ous / WRATH CON / SU-ming the / SOULS of his /
 FEL-low a / CHAI-ans
HURLED ere their / TIME TO / PLU-to's black / DOOR YET /
 ZEUS did a / LOW it;
TELL me the / MAN or the / GOD who be / GAN such a /
 DEAD-ly col- / LI-sion.

The extreme length of the epic line has prevented it from being used in any major way by poets writing in English, though Longfellow's "The Midnight Ride of Paul Revere" catches some of the feel of the line. Most translators today, following Milton, simply translate Homer and Virgil into blank verse—though the great Richmond Lattimore used a line that, though it does not scan regularly, has six stresses.

(At the risk of confusing the reader somewhat, I feel duty bound to add that Greek and Latin poetry are not based upon stress or accent, but upon the "length" of the vowel. "Pain," "meat," and "wine" all have long vowels; "pan," "met," and "win" all have short vowels. For Homer and Virgil, a dactyl is not formed by a stressed syllable followed by two unstressed syllables but by a long vowel followed by two short ones.)

One further type of epic meter that also does not make use of rhyme is **alliterative verse**, made famous by the Old English (or Anglo-Saxon) epic, *Beowulf*. Much shorter than Homer's dactylic hexameter line, alliterative verse offers an alternative to both standard rhythm and rhyme. Instead of being built on a set poetic foot, the alliterative line consists of four stresses, with great variation in terms of the number of syllables. The four-stress line is further broken into two halves, with a pause, or **caesura**, at the center of each line. Though alliterative verse is unrhymed, each line is unified by alliteration, the repetition of two or more words that have the same initial sound: in most cases, the first consonant.

J. R. R. Tolkien, one of the great *Beowulf* scholars, includes a brief alliterative poem in book 5, chapter 6 of *The Lord of the Rings* (I have marked the caesura with a // and marked the alliteration with bold type):

> Out of **D**OUBT, out of **D**ARK // to the **D**AY'S RI-sing
> I came **S**ING-ing in the **S**UN, // **S**WORD un-**S**HEATH-ing.
> To **H**OPE'S end i RODE // and to **H**EART'S BREAK-ing:
> Now for **WR**ATH, now for **R**U-in // and a **R**ED NIGHT-fall!

FREE VERSE AND THE LOSS OF COSMIC ORDER

It remains to consider why the majority of twentieth-century poets abandoned traditional meter for a sort of "formless form" known as **free verse**. In free verse—early examples of which can be found in the nineteenth-century American poet Walt Whitman—there is no rhyme and no set meter. Though the poem is still written in lines, though it often makes use of irregular stanza-like units, and though the best free-verse poets infuse their poems with a strong rhythmic feel, the lines do not scan and are not built upon a set poetic foot. Though many critics of modern poetry accuse free-verse poets of a lack of discipline, an excess of self-indulgence, and even a streak of laziness, I believe that the post–World War I abandonment of traditional meter masks a deeper shift in the arts.

Until the modern period, many, if not most, poets believed that they lived in a universe fraught with meaning and beauty. By making use of set aesthetic forms—whether in poetry, the visual arts, or music—the creative geniuses of Europe and America attempted to reflect that cosmic order and balance. Even if they did not believe in the God of the Bible, they did perceive a purpose and a harmony that ran through nature and the mind of man. Their poetry sought to embody that purpose and harmony and to make a real and lasting connection between that which is beautiful, that which is good, and that which is true.

In the best traditional poetry, the link between the form of the

poem and its meaning is neither mechanical nor arbitrary. There is, rather, an intimate link between the chosen stanza and meter and the intellectual and emotional message that the poem embodies, an intimate link that is, at its highest, like the ultimately indissoluble link that God forged between the human body and the human soul. In orthodox Christian theology, the body is neither a prison for the soul, as it was for the Gnostics and neo-Platonists, nor an organic machine to be distinguished from the wholly immaterial soul, as it was and is for the heirs of Descartes. We are not souls inhabiting bodies but enfleshed souls or ensouled bodies: fully physical and fully spiritual, even as the incarnate Christ was fully human and fully divine.

Poetry, when it is most worthy of itself, is incarnational, fusing form and content, sound and sense into a two-into-one union. The aesthetically beautiful forms of traditional poetry are good, even as the body God created for us is good. Yes, we, our world, and our arts are fallen, but the hand of the Maker persists, and we pay homage to that Maker when we fashion a beautiful body to house (incarnate) the artistic ideas that he inspires in us. The modern Western world has, in many ways, lost its perception of and belief in a world of order, beauty, and purpose, and that loss is partly reflected, I believe, in the abandonment of traditional meter.

But it is not too late to get it back! Next time you are in church and there is a lull in the sermon, pull out the hymnal from the pew and start scanning the hymns. And as you do so, train your ear to hear and your spirit to feel the subtle stresses and motions of a rhythm that is as quietly insistent as the flowing of the blood, the tilting of the earth, the spinning of the spheres.

✚ 2

WORDS AND IMAGES

One of the things that makes poetry unique is its heavy reliance on **figurative language**: similes, metaphors, symbols, and so forth. Many students (and adult readers!) think that poets use such language to make their poems sound "flowery" and abstract. "Why can't poets say what they mean directly and simply?" the frustrated student complains. "Why must they load their poems with images that obscure the meaning and make everything fuzzy and indistinct?" Well, if we are speaking of bad, or at least unskilled, poets, then the criticism has merit. But not if we are speaking of the great poets of the Western canon. Poets such as Chaucer and Shakespeare and Donne and Keats use figurative language not to make their poems more fuzzy and indistinct but to make them more concrete and precise.

Poetry, I teach my students, is the most condensed type of language known to man. Through its subtle use of figurative language, allusion, and connotation, poetry empowers the poet to say and suggest the most in the shortest amount of words. Before listing and analyzing the various forms of figurative language, let us consider these other two devices that lend poetry its almost magical ability to distill language down to its essence.

CHAINS OF ALLUSION

The **allusion** is a device used by all artists working in all mediums, but it is particularly central to poetry. By using one or more allusions to a past work of literature, a historical event, or a theological-philosophical concept, a poet can build a bridge between

his own poem and all the poems, ideas, and struggles that came before. Allusions are a kind of aesthetic shorthand that allows the poet to draw into his poem a full range of possible meanings—and to do so with the greatest linguistic economy.

Simply mention the word "Eden" in a poem, and a hundred images rush in: half of those images will be linked to a garden of perfect bliss, joy, and innocence; the other half will be of the pain, sorrow, and alienation that accompany the loss of that garden. And not only Genesis 1–3 will be called up: because one of the central works of English literature is *Paradise Lost*, a reference to Eden will call up various aspects of that epic poem; because the myths of pre-Christian peoples such as the Greeks and the Romans contain Eden-like stories, a reference to Eden will also call up the classical yearning for the Golden Age. If a poem includes a reference to blood on a hand, the reader will immediately recall the image of Lady Macbeth vainly trying to wash the invisible blood from her hands: "Out, damn spot!" If the image of a floating dagger is also invoked in the same poem, then the allusive link to *Macbeth* becomes even stronger, and the reader will assume that the poem is meant in some way or other to comment on the main themes of Shakespeare's Scottish play. (Helpful hint to students: if your teacher asks you to identify the source of an allusion in a poem, guess either Shakespeare or the Bible; if you do, you will be right 75 percent of the time!)

Of course, the good poet will use a word like "Eden" or the images of a bloody hand and a floating dagger only if he *wants* images from Genesis and *Macbeth* to "invade" his poem. Whereas weak or immature poets fill their poems with random allusions in hopes that they will lend their poems weight and substance, skilled poets choose carefully what allusions to include, and, just as importantly, what to leave out. The same is true for film directors. Still, the well-chosen allusion can both enrich a poem and even add to it multiple layers of meaning. Let us say that I have

been asked by someone to do something very difficult: something that I do not want to do (for I know it will cause me great physical and/or emotional pain), but that I know I must do (for it is, in fact, the *right* thing to do). And let us say further that I struggled all last night to make my decision and that by the end of the evening, I had pledged to go through with the difficult thing. If I were writing a poem about the experience, I could explain it as I did above, or I could invoke a single word-picture: Gethsemane. Even if my struggle was not spiritual in content, even if I were myself an atheist with no belief in Jesus or God, I could still, by calling up the image of Jesus praying in the garden of Gethsemane, draw into my narrative all the angst and passion of Christ.

Although many look upon poetic allusions as nothing but a game for English majors and their professors, and although some poets do use them merely as a way to show off their esoteric knowledge, allusions serve a much higher function within literature in general and poetry in particular. Allusions bear testimony to the fact that all the finest poems, and even many that are not so fine, are but so many stanzas in that greater poem that all of humanity has been writing collectively since the dawn of civilization. Though the great poems can and do stand alone, they are best understood and appreciated as existing in conversation with all the other great poems that have ever been or ever will be written.

The power of allusion may be experienced in its fullest form in the New Testament, where allusion often overlaps with prophecy. When Jesus claims (John 10) that he is the Good Shepherd who lays down his life for the sheep, he invokes, simultaneously, a multitude of images from the Old Testament:

- Abel, Genesis 4:2 tells us, is a shepherd, as are Abraham and the nomadic patriarchs; Jacob, the father of the twelve tribes, is a particularly gifted shepherd with a divine knack for breeding sheep (Genesis 30).

- Moses works as a literal shepherd but then metamorphoses into a national leader whose purpose is to lead and guide his flock from the muddy streams of slavery to the green, abundant pastures of the Promised Land (see Isa. 63:11 and Ps. 78:51–55).
- With the rise of the kingdom and its great shepherd-king, David—who also worked as a literal shepherd—the shepherd imagery shifts subtly (see Ps. 78:70–72). King David is both a sensitive shepherd who plays his harp to soothe the troubled Saul (1 Sam. 16:23) and a strong and courageous shepherd who protects his sheep from all harm, no matter the danger to himself (1 Sam. 17:34–35).
- David is the supreme shepherd and yet he sings (in Psalm 23) of a greater Shepherd who, unlike the false shepherds of Israel (against whom the prophets speak incessantly, e.g., Jer. 25:34), truly provides for the needs of his flock.
- The Jewish people, meanwhile, are portrayed as lost sheep who have been led astray by false shepherds (see Jer. 50:6).

And the allusive chain goes on and on and on. In the end only the Messiah can sum up within himself the full legacy of Old Testament shepherd imagery and restore/save not only the lost flock of Israel but that wider sinful flock that encompasses the entire human race (Isa. 53:6).

CLUSTERS OF MEANING

Just as a careful use of allusions allows poems (and the inspired Word of God) to exist in the midst of a larger poetic (and prophetic) community that stretches out across time and space, so a careful use of connotations allows the words that make up the poem to exist in the midst of a larger linguistic community. Whereas a word's **denotation** refers merely to its dictionary definition, its **connotation** refers to the full constellation of meanings that cluster around it. Though good prose writers will, of course, choose their words carefully, poets lavish far more attention and care on each and every word, for in poetry the individual words "count" more than they do in prose. As such, the poet must be

aware of the words and feelings that are associated with each word that appears in the poem.

Perhaps the simplest way to highlight the difference between denotation and connotation is to consider two synonymous words that have the same denotative meaning but vary wildly in their connotative meaning: *house* and *home*. Though these two words share the same basic dictionary definition, the second carries with it a full range of connotations that do not cling to the first. Just meditate for a moment on the word *home*, and you will discover how quickly a host of associations gather around you: feelings (joy, warmth, comfort), images (a lonely attic, a toy-filled nursery, a bedroom with pennants and ribbons on the wall), smells (home cooking, the faint aroma of pipe smoke on the porch, the musty smell of the basement), sounds (people singing carols around the piano, the laughter of cousins, a squeaky rocking chair), and even phrases (there's no place like home, home is where the heart is, home sweet home). Here are some other synonymous pairs, the second of which is richer in connotative meaning: rescue and redeem, expensive and precious, autumn and fall, remain and abide, calm and peace.

Though connotations, like allusions, expand the possible range of meanings, they do so for the purpose not of abstraction but of precision. They build a boundary around the poem that, paradoxically, frees it to have more rather than less meaning. The well-chosen word, image, or allusion *freezes* a thought or emotion for all time. It gives what Shakespeare calls "a local habitation and a name" to something that is abstract and formless. We all know intellectually what jealousy is, but when Shakespeare calls it the "green-eyed monster" (in *Othello*), then we feel that we *really* know what it is. We can speak of young impulsive love that contracts the whole world into a fleeting glance or a swift but passionate embrace, but when we call to mind the balcony scene from *Romeo and Juliet*, we experience that love viscerally. Most of the

greatest poetry concerns itself with abstract nouns (love, beauty, justice, truth, honor, courage) or emotions that cannot be seen, heard, tasted, smelled, or touched. To embody such ideas and emotions, poets must resort to what T. S. Eliot called an "objective correlative": an image or event or thing in our concrete (objective) world that correlates to an abstract idea or subjective feeling.

My favorite objective correlative is to be found in the *Iliad*, a poem that claims to be about "the wrath of Achilles." But how to show wrath, how to embody (or incarnate) it in a concrete image that will allow the reader to experience both the idea and emotion of wrath? Homer finds a powerful vehicle for doing so in book 18 of his epic. Achilles has just learned of the death of his friend Patroclus and is eager to reenter the battlefield and wreak vengeance on the Trojans, but he lacks a suit of armor. Eventually he is given a set of divine armor made by Hephaestus, the blacksmith of the gods; however, while he waits for it, he yearns to help his fellow Greek soldiers and to unburden some of his swiftly mounting wrath against the Trojans. As a way of (literally) letting off steam, Achilles walks up to the battlefield and unleashes from his furious chest a terrifying war cry. So terrible is that cry, Homer tells us, that immediately a dozen of the finest Trojan warriors are crushed by chariots or fall upon their own swords. What better way to capture wrath than to show the deadly panic induced by Achilles's *cri de coeur*!

Again, what poetry seeks is not abstraction but concreteness, not haziness but precision. Until the twentieth century, that precision was mirrored equally in form and content, in the careful manipulation of rhythm and rhyme on the one hand and words and images on the other. Out of the intense synergism of form and content was born a poetic artifact that fused the polish of the craftsman with the passion of the lover, the artisan's skillful hand with the rebel's flaming torch. Unfortunately, that synergism has, in many ways, broken down. For a century now, armies of poets

and critics have sought to cast off traditional metrical schemes and stanza forms as they would a straightjacket. They thought that by doing so they would liberate the imagination and allow creativity to thrive. Alas, like most of the utopian promises of the modern world, free verse has more often crushed meaning than enhanced it, turning poets inward and trapping them in a suffocating prison of egocentric, if not narcissistic, self-expression.

Christ teaches that the only way we can be truly free is to surrender to him, and that the only way we can gain our life is to lose it. In a parallel way, the great poets who have "enslaved" themselves to rigid meters have found in it a discipline, an order, and a hierarchy that have made them more, not less, creative. There are few stanza forms more exacting than that of the sonnet, and yet the form has proved to be inexhaustibly fruitful. Just when it seemed that Sidney and Shakespeare had squeezed every ounce of potential out of the sonnet, along came Donne to reinvigorate the form, and then Milton, and then Wordsworth, and then Keats. Free verse, which *seemed* to offer unlimited potential for creativity and experimentation, was exhausted long before the end of the twentieth century.

Wordsworth explains it best in a sonnet that is about sonnets:

Nuns fret not at their convent's narrow room;
And hermits are contented with their cells;
And students with their pensive citadels;
Maids at the wheel, the weaver at his loom,
Sit blithe and happy; bees that soar for bloom,
High as the highest Peak of Furness-fells,
Will murmur by the hour in foxglove bells:
In truth the prison, into which we doom
Ourselves, no prison is: and hence for me,
In sundry moods, 't was pastime to be bound
Within the Sonnet's scanty plot of ground;
Pleased if some Souls (for such there needs must be)

Who have felt the weight of too much liberty,
Should find brief solace there, as I have found.

As if to drive home his point, Wordsworth "imprisons" himself within the demanding Petrarchan form, using a rhyme scheme that allows for only four rhyming sounds spread out over fourteen lines: *abbaabbacddccd*. The point of the sonnet is quite clear and direct: just as nuns, students, and weavers are inspired rather than enervated by their confinement to narrow parameters (whatever the exact nature of those parameters might be), so the poet finds peace rather than bondage in the narrow walls of the sonnet. Indeed, he finds within the sonnet release from the heavy weight of "too much liberty": a weight that is itself a form of bondage.

And yet, though Wordsworth not only confines himself to the narrow room of the sonnet but celebrates that confinement, he nevertheless finds ways to assert his individuality *within* that confined space. First he begins his iambic pentameter poem with not one but two substitutions:

NUNS FRET / NOT at /their CON / vent's NAR / row ROOM

Wordsworth substitutes for his two initial iambs a spondee and a trochee. It is as if in bowing to authority he simultaneously throws down his gauntlet! But he goes further. Though he divides his Petrarchan sonnet into the expected octave and sestet—with the former focusing generally on nuns, students, and weavers, and the latter focusing personally on Wordsworth the poet—he breaks quite radically with tradition, in placing his turn ("In truth") at the beginning of line eight rather than the beginning of line nine. This changes the balance of octave/sestet from 8/6 to 7/7, thus *equating* the poet's own personal experience of confinement with that of all the other "professions" combined.

Many in academia today have complained that college freshmen are woefully deficient in their biblical knowledge. Christians

who have immersed themselves in the Bible and who have developed habits of reading God's Word carefully and in its proper context come to college with a double advantage: not only do they recognize the scores of biblical allusions that dominate the works of Chaucer, Spenser, Shakespeare, Milton, Wordsworth, and Tennyson, but they are aware of the connotative richness that clusters around such words as *creation*, *fall*, *redemption*, *justification*, *regeneration*, *revelation*, and even the word *word* itself. But their advantage goes further than this. To know the Bible intimately is to understand how strings of allusions, like the shepherd string discussed above, give meaning and purpose to a world that at first glance may seem chaotic and random. Furthermore, the ability to grasp the thematic patterns that are written into connotatively rich words like *creation*, *fall*, and *redemption* is to have one's eyes opened to the greater weave of history, to the overarching story (or metanarrative) that includes all other stories within itself.

FREEZING THE IMAGE

But let us turn our attention now to more image-based devices that poets use to achieve precision, namely, to that figurative language which is the very life-blood of poetry.

At the heart of figurative language stands the humble **simile**, a figure of speech (or trope) in which one thing is compared to another thing: *x* is like *y*. The famous boxer Muhammad Ali once coined a catchy truncated dactylic tetrameter line to describe his unique boxing style:

FLOAT like a / BUT-ter-fly / STING like a / BEE ___ ___

On the surface, this seems like a ridiculously inapt simile. In what sense can a powerful boxer be compared to two insects? The simile appears to be a false one until we remember that what was unique about Ali's style was that, though his punches were deadly, he was extremely light on his feet. Despite the force in his two stingers

(his fists), he moved with the balletic grace of a butterfly. Indeed, what makes the simile work so powerfully is that Ali is actually yoking together two different similes (the butterfly and the bee) to create a moving picture. Imagine watching a delicate butterfly flit from flower to flower. You smile at the beauty of the movement, but, as you watch with lazy eyes, the butterfly metamorphoses into a bee, turns its stinger toward you, and attacks. Now, Ali could have simply said, "I'm graceful but I'm deadly," but his use of figurative language makes that statement real and concrete: embodying and enshrining it for all time.

Here is a more complex simile (one that uses "as" rather than "like") from a sonnet by Wordsworth:

> It is a beauteous evening, calm and free.
> The holy time is quiet as a Nun,
> Breathless with adoration.

In a way, this simile is even odder than the ones used by Muhammad Ali. What possible link could there be between a beauteous evening and a nun at her prayers? To solve this riddle, we must first determine what exactly it is Wordsworth is trying to describe. He's trying to capture a specific emotion or mood that falls upon us when we are in the presence of something that is both breathtakingly beautiful (a sunset over the sea) and disturbingly calm. We want to cry out with joy, but everything is too solemn and too still to be broken by a loud sound or a sudden gesture. It is what happens after an audience listens to an aria sung by a great opera star: between the end of the aria and the thunderous applause, there is a suspended moment when a hush falls over the crowd, when they are too full to move or yell or applaud. How is Wordsworth to capture, in a concrete image, this paradox of frozen passion and quiet intensity?

He does it by shifting our attention to a nun saying vespers. The nun's passionate love for God fills her heart with adoration,

but she does not express that adoration with shouts or gesticulations. She holds the joy within her while lifting it up to God—more than that, she feels (like the great mystics of the church) an almost erotic joy that is nevertheless chaste and nonphysical. Although the poet is interacting more with nature than with God, it is appropriate that he compare his emotion/mood to that of a nun: for what he is sensing is something that might best be called holy or sacred. Indeed, only the mystical love of God that the nun feels can adequately point to the higher mode of passion, wonder, and awe that seizes the poet as he gazes on and participates in the beauteous evening. Like the hushed crowd at the end of the aria, both nun and poet are breathless, suspended between physical movement and silent rapture.

Here's one more simile from a song, in ballad rhythm, by Robert Burns (the author of "Auld Lang Syne"):

> My love is like a red, red rose,
> That's newly sprung in June;
> My love is like a melody
> That's sweetly sung in tune.

Is there a difference between "a red rose" and "a red, red rose"? On the denotative level, not really, but in terms of how we react emotionally to the repetition of the word "red," most definitely yes. By the simple repetition of a word, the poet suggests a redness that is deeper than all red—the redness that clings to the heart and that moves the blood of the lover. It is not to any rose, but only to that red, red rose that the poet compares his love—which word signifies both the girl he loves and the love that he feels for the girl.

Like Ali's poetic boast, Burns's stanza offers us a double simile: one that appeals to the eye (the rose), and one that appeals to the ear (the melody). The first simile is natural and calls up all the freshness of early summer; the second is man-made and strives to capture all the sweetness of which human creativity is capable.

Held in tension between flower and song, eye and ear, natural and artificial, the love of the poet gains a kind of aesthetic immortality; it is precise in a way that no prose paraphrase can quite express. It is just *right*.

My high school teacher, like most high school teachers, taught me that the difference between a simile and a **metaphor** is that the first uses "like" or "as," and the second does not. Although this definition is technically correct, it misses out on the deeper distinction between a simile and a metaphor. Whereas the simile simply presents us with a comparison, when we turn to the metaphor, the process becomes more magical, for this time, the poetic image almost fuses with the object it is compared to: x is y.

When we read, in Shakespeare's *As You Like It*, that

> All the world's a stage,
> And all the men and women merely players

we are drawn into a direct encounter with the wonder-working properties of metaphor. Far from being merely *like* a stage, the world is transformed, by the magic of Shakespeare's art, *into* a stage. In a sudden flash of poetic insight, we see that we are all players acting out the separate dramas of our lives on the raised stage of the world. Shakespeare's metaphor does not so much create this truth as baptize our eyes to see a truth that already exists but that we have never before glimpsed—not because the world is strange to us but because it is too familiar!

In Sonnet 116, Shakespeare also uses metaphor to open our eyes to a truth we too often miss, this time to the nature of true, self-giving love (*agape* in Greek, *caritas* in Latin):

> O, no, it [love] is an ever-fixéd mark
> That looks on tempests and is never shaken;
> It is the star to every wand'ring bark,
> Whose worth's unknown, although his height be taken.

In this, the second quatrain of the sonnet, Shakespeare uses a double metaphor to reveal one of the qualities that defines *agape*. On the rough seas of our lives, we (or, more precisely, our hearts and souls) are like lost ships struggling to weather the storm and to stay on course. Love is Polaris, the North Star, a fixed point in the sky by which we can guide our wandering boats to a safe harbor.

Yes, love is not literally a star—it is only *like* a star—and yet, through the magic of Shakespeare's metaphor, we realize that in some sense it *is* a star, for we *are* ships (not *like* ships) lost in the storm. We all need in our lives something that is stable and constant, that does not change or decay or grow old. Think of that wonderful moment in Matthew (14:22–33) when Peter steps out of the boat and begins to walk on the water. As long as he keeps his eyes focused on Christ, he remains above the storm, but when he turns from Christ to look upon the wind and the waves, he loses his focus and begins to sink. As Christ, the bright morning star, keeps us on the right path toward God the Father, so does love, the North Star of our heart and soul, keep us on track in the midst of life's storms and troubles. The North Star, though its distance from the earth can be measured in miles, is of inestimable worth to sailors on the high seas; just so, love is not a thing on which we can place a price tag—its value exceeds that of rubies and pearls.

TRAFFICKING BETWEEN TWO WORLDS

Although any time a poet uses the formula "*x* is *y*" he is working in the domain of the metaphor, there are four special kinds of metaphors that deserve individual mention.

The first is called a **synecdoche**; it occurs when the whole is replaced by the part or the part by the whole. When Jesus, in the Lord's Prayer, teaches us to say, "Give us this day our daily bread" (Matt. 6:11; see also Luke 11:3), he does not use the word "bread" to signify only wheat. To ask God to supply us with daily bread is to ask him to supply us not only with all the food and drink

we need to survive but also with the clothing and shelter as well. Those of you who have repeated this prayer hundreds, if not thousands, of times might be surprised to know that the Lord's Prayer makes use of figurative language—but that is only because we have heard it so often that it has lost its poetic freshness. Through the magic of the synecdoche, Jesus reduces all our physical needs into the single word-image, bread. In a similar way, when a man proposes to his girlfriend, he asks for her "hand" in marriage. In reality, his desire is to be joined to all of her, both body and soul, but the magic of synecdoche allows him to focus, more genteelly, on that part of her body that will bear the symbol of their union, the wedding ring.

Closely allied to the synecdoche is the **metonymy**, a kind of metaphor in which a thing is replaced by something else closely related to it. When a newscaster announces, "The White House said today," he does not mean to suggest that the building spoke, but that the president, who lives in the White House, made some kind of official statement. Likewise, when a sailor says that he has a date with a "skirt," or a minimum-wage employee says he's been called in to see one of the "suits," neither is planning to meet up with an article of clothing! As with the example from the Lord's Prayer, many of the phrases we use in our day-to-day lives have gotten so worn that we have ceased to realize we are speaking figuratively rather than literally.

This is particularly the case with **personification** (giving human or animal qualities to natural or inanimate objects) and **anthropomorphism** (giving human characteristics to animals). How often do we speak of the "face of a clock" or of an "angry-looking sky" or of a "deceitful cat"? All of these phrases are figurative, but custom and habit have worn off the poetic (and magical) edge. Even the most rational, left-brained engineer uses a dozen or so metaphors a day without realizing it. Indeed, the sciences themselves use metaphors when they appeal to the "laws of nature" (as if rocks and

trees and birds were citizens in a democracy) or line up all the elements in the "periodic table" (which strongly resembles a formal poem, with the inert gases—neon, argon, krypton, xenon, and radon—forming a sort of end rhyme), or trumpet the explanatory power of Darwin's "branching tree of life" (a true poetic construct if there ever was one, since the fossil record not only does not support the tree, but actually contradicts it).

Our inclination to personify the natural world, like our tendency to attribute human emotions and traits to our pets, seems to be hardwired into us (if I may use another scientific metaphor). We are not just the rational animal; we are the poetic animal as well. It is for this reason, I believe, that we are so often unconscious of the metaphors we use. That is less true, however, of two other types of metaphors that are far more overt than the synecdoche and the metonymy: **allegory** and **symbol**.

In an allegory (still x is y) the poet chooses an idea or an emotion and then embodies or incarnates that emotion in the form of some concrete representation. Allegory is easiest to see in a political artist like Delacroix, who allegorizes liberty as a giant woman carrying a banner and a bayonet and leading the people to victory. In the realm of literature, the best-known use of allegory is to be found in John Bunyan's *Pilgrim's Progress*. In a prose style that is often richly poetic, Bunyan transforms the spiritual walk of the Christian into a journey—taken by an allegorical figure who is named, appropriately, Christian—through a landscape peopled by invented figures that represent such temptations as doubt, despair, and vanity. Any believer who has struggled with despair will know how easy it is to become dwarfed by the all-encompassing feeling that he has been abandoned by God. In an attempt to embody that feeling and that struggle, Bunyan allegorizes despair as a giant who captures Christian and throws him into a dungeon deep within Doubting Castle. There Christian remains in the dungeon of doubt and despair until he realizes that in his pocket he carries

the Key of Promise, which will open up the prison doors and set him free.

Like allegories, symbols also forge a connection between something physical (the Giant Despair) and something nonphysical (the experience of despair). This time, however, the connection between the two is more intense, more mystical, more incarnational. There is in symbol a special kind of vibrancy lacking in allegory. Whereas allegorical figures (like Bunyan's Giant Despair) have no separate existence of their own—they are fictions, fantasies conjured up to illustrate and explain—symbolic objects have an existence and integrity separate from what they point to: they are, simultaneously, themselves and something more than themselves. As such, a symbol can function as a nexus, a way-station; like Christ himself, it is a meeting ground where human and divine not only cohabit but, for a brief, magical moment, fuse. In a symbol, the temporal does not merely point to the eternal; the eternal is perceived and experienced *through and in* the temporal.

Perhaps the supreme example of a symbol can be found in the Catholic understanding of the Lord's Supper. The Catholic Church teaches that during the Mass, the bread and wine become the body and blood of Christ—and yet they continue to remain bread and wine. What happens during the Mass is nothing less than a "trafficking" between earth and heaven, between the physical products of the grain and the grape and the body and the blood of Christ—and not just the physical body and blood that were broken and shed on the cross, but the eternal body and blood of the Lamb that was slain from the foundation of the world. For Catholic theologians, the Eucharist, like all seven sacraments, bears witness to the incarnation, for its two-in-one nature helps build a bridge between earth and heaven, the human and the divine. I often joke with my fellow evangelicals that there is more magic in Catholicism than in Protestantism. In a Catholic church, they begin with bread and wine, but these

mundane elements are mystically transformed into the body and blood of Christ. At my Baptist church, we also begin with bread and wine, but the bread stays bread and the wine is mystically transformed—into grape juice!

In a number of his essays and letters, C. S. Lewis insisted that Aslan was not, technically speaking, an allegory for Christ. If he were an allegory, then he would be nothing more than the Giant Despair—a stand-in for Christ who possessed no life or integrity of his own. But that is not what (or who) Aslan is. Rather than being an allegory for Christ, Lewis explained, Aslan is the Christ of Narnia. He possesses full integrity as the messianic Lion-King of Narnia, but he embodies, simultaneously, the essence of the second person of the Trinity. Aslan is not one masquerading as the other; he is both at once.

Symbols are truly mystical in their ability to commune between two worlds, and yet, paradoxically, the symbolic object itself (bread, wine, lion, cross, lily, bell, ring, and so forth) possesses no essential meaning nor any inherent meaning-giving power; what power it has is "poured" into it from without by the symbolist. And yet again, equally paradoxically, the only reason the symbolist *can* pour meaning into the object is that it is already there, placed there from the beginning by the One who created "all things . . . visible and invisible" (Col. 1:16). Now, all this is not to say that symbols can function only in a religious context; secularists, agnostics, and atheists have all made use of symbolic language. Still, the symbol is, at its core, both mystical and sacramental. Symbols bear witness to a world full of meaning, purpose, and design, even if that meaning is sometimes cloudy, that purpose seemingly arbitrary, and that design apparently skewed. They are like the rocks that Jesus says will cry out in witness if human voices fail to praise (Luke 19:40).

Though the symbol represents only one type of metaphor, it points, I believe, to a deep and profound truth that lies at the heart

of all metaphors. And that truth is simply this: that *everything* in our world, if seen properly, is a metaphor. It is a shame that so many people dismiss poetry as "mere" fiction, when it is the poets who have helped us to see this great truth about ourselves and our world. The world is full of meaning and mystery and magic: we, *especially* if we are Christians, just need eyes to see and ears to hear.

✚ 3

AGES, AUTHORS, AND GENRES

In the previous two chapters we considered poetry from the point of view of rhythm and rhyme, which are its skeleton, and word and image, which are its viscera, its nerves, and its lifeblood. The time has now come to put flesh on the bones and carry the creature thus completed into the world of time and space. I shall do this by considering those authors and genres of literature that have had the most influence and have endured the longest, as well as the major historical-aesthetic ages through which the march of Great Books has proceeded.

You will note that I use the word *proceeded* rather than the word *evolved*. Though one can say, with a fair amount of accuracy, that science, medicine, and technology evolve and progress from age to age, literature (and the humanities in general) does not. Our modern age has produced many great thinkers but no one quite on the level of Plato or Aristotle or Virgil or Augustine or Aquinas or Dante or Shakespeare. I do not say this to disparage the last few centuries, but to teach us all, myself included, a bit of needed humility. Yes, we today know more than those great thinkers did, but that is only because—if I may paraphrase a line from T. S. Eliot—they and their works make up a significant part of what we know. And besides, there is a great difference between the accumulation of facts and true aesthetic (or philosophical or theological) genius.

Mesmerized as our age is by evolution, we too often take for

granted that all the people of the past—especially the Medievals—were backward and unenlightened. In fact, back then, as today, there existed both wise men and fools, deep thinkers and shallow thinkers, the enlightened and the ignorant. Our tastes and our cultures and our social-political-economic structures change from place to place and time to time (sometimes for the better, sometimes for the worse), but human nature does not. That is why, when I teach the *Iliad* and the *Odyssey* to college freshmen, I only need to give them a small amount of cultural and historical background before they begin to connect with the characters as "real" people whose intellectual, emotional, and spiritual struggles and needs are not so very different from their own.

G. K. Chesterton reminds us, in *The Everlasting Man*, that the records we have for Egypt and Babylon—records that date back to the very dawn of human culture—show them *already* to be highly advanced. Indeed, those who study the history and archeology of the ancient world are as often greeted by the de-evolution of civilization as by its growth and progress! During my senior year in high school, I remember taking a literature/history class titled "From Barbarism to Humanism." When I learned that the class was to begin with the ancient Greeks and end in the twentieth century, I asked if the class should not more accurately have been titled "From Humanism to Barbarism." I didn't ask the question to be a wise guy (well, maybe a little bit; I was eighteen, after all!), but because I knew even then that the Greeks of the fifth century BC had left a legacy of aesthetic, intellectual, philosophical, and political thought that has never fully been equaled.

The Victorian poet and literary critic Matthew Arnold once argued, in an essay titled "The Function of Criticism at the Present Time," that aesthetic history oscillates back and forth between two kinds of eras that he dubbed **"epochs of concentration"** and **"epochs of expansion."** In epochs of concentration, ideas are stagnant, if not stifled. During such periods, would-be major poets lack the

necessary energy and raw material to fashion enduring works of literature, and, as a result, critical thought gains ascendancy over creative expression. In epochs of expansion, on the other hand, a culture is rich with new and fresh ideas. During such epochs, poets rise to the fore to harness this intellectual energy and convert it into great works of art. Such epochs are rare; in fact, Arnold identifies only two of them: Periclean Athens (that is, the Golden Age of Greece) and Elizabethan England (the age of Shakespeare). Many critics today—myself included, as the remainder of this chapter will show—would add several more periods (the age of Caesar Augustus and his star poet, Virgil; the fourteenth century that begins with Dante and ends with Chaucer; the late Renaissance, which includes Donne, Herbert, Bunyan, and Milton; the Romantic Age that was born out of the French Revolution; the Victorian Age of Tennyson, Browning, and Dickens), but none would dispute the two that Arnold lists.

CLASSICAL GREECE

Date: fifth century BC

Figures: Pericles, Aeschylus, Sophocles, Euripides, Aristophanes, Herodotus, Thucydides, Socrates, Plato (influenced by Homer, Hesiod, and Pindar; followed by Aristotle)

Genres: epic, tragedy, comedy, history, philosophy

Theme: birthplace of humanism

The Golden Age of Greece would not have been so golden had it not been fed by a stream, the source of which originated, seven hundred years earlier, in the Trojan War. Though many still refuse to accept that the *Iliad* is grounded in a real event, there is enough historical, archaeological, and linguistic evidence to provide us with reasonable certainty that an actual war was fought between Greece and Troy during the height of the Mycenaean Bronze Age (1250–1200). Ironically, within two generations of the Trojan War,

all the great city-states that made up the Mycenaean civilization (except Athens) were destroyed, and Greece fell into a dark age during which the art of writing was lost.

Thankfully, at least for those who value the Great Books, two things happened during the Dark Ages that ensured that the light of Western civilization would not go out. First, in order to link Greece back to her heroic past, a vigorous oral tradition developed that kept alive the memory of the Mycenaean Age's last great expedition—the Trojan War. To facilitate this oral tradition, the tales of Troy were put into verse, using the epic meter of dactylic hexameter (discussed in chapter 1). Second, whole villages of displaced Greeks began to cross the Aegean and settle on the Asia Minor Coast (modern-day Turkey). Desperate to keep alive their ties to the mainland, they not only preserved the oral tradition but systematized and codified it, establishing a school of bards who slowly perfected the conventions of epic poetry that Homer would immortalize.

Homer likely lived in the late eighth century on the island of Chios; in the decades just before Greece regained her written language (via Phoenician sailors), Homer collected the tales of Troy into the two long poems that bear his name. In the sixth century, as the Greeks of Asia Minor were slowly falling under the sway of the Babylonians and Persians, Athens slowly rose to political, economic, and aesthetic power. One of her enlightened tyrants (Peisistratus), seeing the value of Homer's epics for fostering national pride, established a festival at which rhapsodes brought in from Asia Minor recited the entire *Iliad* and *Odyssey* over an extended weekend. It is highly likely that the poems were written down during this period. The Athenians, and other Greeks, who defeated the Persian Empire in 480 BC and ushered in the Golden Age, were raised on Homer's epics; from them, they learned not only history, religion, language, and culture, but the virtues that

would transform Athens into the cradle of democracy and the fountainhead of humanism.

Now, I am aware that in identifying Athens as the birthplace of humanism, I risk encouraging many of my fellow evangelicals to thereby dismiss, or at least mistrust, Athens as the "enemy." But please remember that the "enemy" of Christianity—I prefer to use the phrase "competing worldview"—is not humanism per se, but *secular* humanism. One can just as well be a Christian humanist (like Dante, Donne, Milton, Chesterton, and C. S. Lewis) as a secular humanist (like Marx, Freud, Sartre, Bertrand Russell, and Richard Dawkins).

A humanist is not someone who rejects God or the Christian revelation, but one who believes that man is a free and rational creature—one who possesses innate dignity and value, and whose life and achievements on this earth are of intrinsic and lasting worth. A humanist believes in the power of human reason and creativity to shape and change the world and the importance of preserving a record, in various mediums, of those shapings and changes. A humanist believes, to borrow a key humanist phrase, that "the proper study of man is man," not because God is unimportant or irrelevant but because man's innate dignity demands such attention. Such humanist beliefs are not, I would argue, inconsistent with Christianity; to the contrary, I would assert that the only *true* humanist is the Christian (or at least theistic) humanist. If the secular humanists are correct and man is merely the product of undirected time and chance, then he is certainly not worth the attention that the secular humanists lavish on him; but if we are, as the Bible teaches, creatures made in the image of God, then our hopes and fears and desires are supremely worth studying and preserving. Further, if the God who created us thought us of enough value to become one of us and to die for us, then who are we to dismiss man as a poor forked animal evolved out of primordial slime and destined only for extinction?

I said above that the Golden Age of Greece constitutes the root and first flowering of humanistic thought, and, as such, I believe that Greek art, history, philosophy, politics, *and especially literature* must form the basis of any true humanistic (liberal arts) education. Let me be even bolder: no one can be a *true* student of literature unless he is a humanist. If you reject the notion that man is the proper study of man, and that the things man creates are of value and worth preserving, then why study literature at all? From it you will learn nothing "practical"; it won't put money in your purse or bread on your table. But from it you *will* learn to understand yourself and the human race better. You will earn the privilege and the right to participate in the flow of human ideas and to grapple with the major expressions of the human imagination. You will be invited to join the great conversation! No, such a study will not put you back into a right relationship with God (only Christ can do that), but it will help to shape you into a good and noble citizen who seeks both to enrich your society without and to fulfill within the Socratic mandate: Know Thyself.

At this point, some of you may be wondering how the Greeks of the Classical Age could have learned all these things from reading **Homer**. Perhaps the best way to answer this question is to consider the key elements of the epic genre as they were incarnated by Homer (late eighth century BC) and later imitated by such epic poets as Virgil, Dante, and Milton. An **epic** is a long poem on a heroic subject that, despite its many digressions and repetitions (indicative of its origin in the oral tradition), focuses on the internal and external struggles of a hero who has, in some way or another, been chosen and set apart. Thus, while the *Iliad* centers on Achilles's wrath not only against Agamemnon and Hector but also against his own impending mortality, the *Odyssey* centers on Odysseus's attempts not only to return home but to preserve his own identity in the process. At its highest, humanism explores and celebrates our struggle (as individuals and as a species) to come to

grips with our purpose and our identity in the face of death and decay, and of an intractable, often hostile natural world.

The epics of Homer embody that struggle and then intensify it by inscribing it along two levels of action: the mortal and the immortal, the human and the divine. Throughout both epics, the constant presence of scheming deities who need not fear death, loss, or separation increases many-fold the anguish and suffering of the heroes. The heroes are further circumscribed within a complex weave of social and familial obligations, codes of honor and behavioral expectations, personal destiny and overarching fate. Rather than introduce us slowly to this complex weave, Homer plunges in *in medias res* ("in the middle of things"), so that when the epic opens, all the struggles and tensions are already near their height. The epic is a proving ground for virtuous action, and it instilled in the Athenians of the fifth century both the courage to resist Persian tyranny and a sense of their unique calling as a people. The democratic structures that they built attested to that calling and to their increased faith that man was not destined to be a slave to tyranny but to build a city on a hill.

That epoch of expansion that was the Golden Age of Athens gave us **Phidias** (fifth century), the great architect of the Parthenon and sculptor of the Athena; **Pericles** (c. 500–429), a towering statesmen and the true forerunner of Abraham Lincoln; **Herodotus** (c. 480–425), the father of narrative history and cultural anthropology; **Thucydides** (471–400), the father of analytical history and political science; **Socrates** (c. 470–399), the true founding father of philosophy; and the young **Plato** (c. 427–347), my choice for the greatest philosopher of all time. More to the point of this book, Periclean Athens gave birth to the genre of tragedy and to three of its greatest practitioners: **Aeschylus** (525–456), *Oresteia*; *Prometheus Bound*; **Sophocles** (c. 496–406), *Oedipus*; *Antigone*; *Electra*; *Ajax*; and **Euripides** (c. 480–406), *Medea*; *Bachae*; *Hippolytus*; *Trojan Women*.

Tragedy was the defining art of Greek democracy. Though all but one of the extant tragedies of Aeschylus, Sophocles, and Euripides are set in the legendary heroic age that extends from two generations before the Trojan War to one generation after it, they are all deeply concerned with the issues and struggles that defined life in the polis (city-state) of Athens: eye-for-an-eye vengeance versus rule by law; claims of family versus claims of state; chaos versus order; free will versus predestination; the feminine-emotional-intuitive-physical versus the masculine-intellectual-logical-spiritual; the voice of the dispossessed outsider versus the authority of the powerful insider. In addition to dramatizing such struggles before the citizens of Athens, tragedy also drew into itself the often competing claims of the political, the social, the ethical, and the religious. And it did so through a two-tiered generic structure that engaged the full body of citizens. Just as the epic was played out on two levels (the divine and the human), so tragedy represented, in part, an encounter between the political and economic aristocracy (embodied in the actors, who were always taken from the royal families of legend) and the common citizens (embodied in the **chorus**, a group of nonroyal characters who spoke in unison and who, in nearly all the plays, took the part of the status quo). In the interaction between actors and chorus—who actually *stood* on two levels, with the chorus on the same level as the first row of seats and the actors standing behind them on a raised platform—we witness one of the greatest challenges of a democracy: to balance the claims of rich and poor, the elite and the mass.

The epic spirit and the democratic gave birth together to tragedy, but it was likely the democratic spirit alone that produced comedy. Unlike tragedy, which focused on noble, aristocratic heroes from the legendary past who spoke in an exalted language, **comedy** turned its focus to common, often ignorant heroes of the present day who spoke in a coarser and usually bawdy language.

Aristophanes (c. 448–380) was the master and virtual inventor of the form, though his comedies differ in two major ways from the later Shakespearean ones with which people today are more familiar. First, the comedies of Aristophanes (*Birds*; *Clouds*; *Frogs*; *Lysistrata*) are strongly topical and political and contain an often savage satirical wit (rather like Jonathan Swift). Second, they do not end in marriage, though they are strongly laced with sexuality and are concerned with social reconciliation. Still, they influenced the rest of Western literature by holding up a competing vision to the tragedies of Aeschylus, Sophocles, and Euripides.

CLASSICAL ROME

Date:	27 BC–AD 14
Figures:	Caesar Augustus, Horace, Virgil, Ovid, Livy (influenced by Alexandrians, Cicero, Catullus, and Lucretius; followed by Juvenal and Petronius)
Genres:	epic, mock epic, pastoral, satire, lyric, verse epistle, history
Theme:	self-conscious artistry

By the end of the fifth century, the Golden Age was over, but its ideas and innovations were preserved in the work of the fourth-century philosopher **Aristotle** (384–322). Aristotle, the pupil of Plato, would go on to tutor **Alexander the Great** (356–323), who would go on to conquer the world. Alexander would spread Greek (Hellenistic) culture throughout the Mediterranean, and beyond, and would lay the foundation for Alexandria, Egypt. After his death, Alexandria would become the first "college town," boasting both a great library/museum and a living collection of the world's greatest scholars. It was here that Homer's epics were edited and here too that the Old Testament was translated into Greek (the Septuagint). Though the poet-scholars of Alexandria all but worshiped Homer and the tragedians, they found personal inspiration in **Hesiod** (eighth century)—a contemporary of Homer who wrote

two shorter epics on the genealogy of the gods (*Theogony*) and on farming (*Works and Days*)—and **Pindar** (c. 522–443)—a forerunner of the Golden Age of Athens who wrote shorter, lyrical poetry celebrating the glory and beauty of Olympic athletes.

In imitation of Hesiod and Pindar, the Alexandrian poets (like their greatest heir T. S. Eliot) abandoned the epic and tragic sweep of Homer and the tragedians to write shorter, more highly polished, more self-conscious poetry. In place of **narrative poetry**, which is strongly plot and character driven, they helped lay down the rules for **lyric poetry**, which is more concerned with emotion, psychological insight, and carefully crafted details. **Apollonius of Rhodes** (third/second century) even wrote a mini four-book epic (*Argonautica*) about Jason's quest for the Golden Fleece that replaces action with psychological insight. The greatest Alexandrian poet, **Theocritus** (third century), invented a new lyrical form known as the **pastoral**, which celebrated the life of the countryside (as Hesiod had done in *Works and Days*) and evoked a nostalgic sense of loss for the simple life. Needless to say, pastorals are written not by innocent farmers but by sophisticated city dwellers who would themselves never actually want to live on a farm! A sub-genre of the pastoral (known as the **pastoral elegy**) combines mourning for a lost person, often a poet, with mourning for a lost way of life. A list of pastorals or pastoral elegies would include Virgil's *Eclogues*; Spenser's *The Shepheardes Calender*; Shakespeare's *The Winter's Tale*, Act 4; Pope's *Windsor Forest*; Milton's *Lycidas*; Shelley's *Adonais*; Tennyson's *In Memoriam*, sections 21–27; and Arnold's *Thyrsis*.

The legacy of the Alexandrians, combined with that of Periclean Athens, helped lay the foundation for the Golden Age of Rome that was overseen by **Caesar Augustus** (63 BC–AD 14), the first Roman emperor, whose reign (27 BC–AD 14) gives the Golden Age both its temporal limits and its alternate name: the Augustan Age. Prepared for in the previous generation by the works of **Cicero** (106–43), a great orator who won for **prose** a reputation nearly as

high as for poetry, **Catullus** (c. 84–54), a lyrical love poet in the tradition of the Alexandrians, and **Lucretius** (c. 96–55), who wrote a mini-epic on the subject of science, the Augustan Age saw the full-flowering of Roman letters. In addition to birthing another master of prose, the historian **Livy** (59 BC–AD 17), the Augustan Age nurtured the genius of three of the Western world's most influential poets: Horace (65 BC–AD 8), Virgil (70 BC–AD 19), and Ovid (43 BC–AD 18).

Horace, the least known today—partly because his carefully crafted, highly nuanced lyric poetry (like that of the German Goethe) seems to defy translation—essentially gave birth to two influential genres, **satire** and the **verse epistle**. Though Aristophanes incorporated satiric elements into his comedies, satire is generally considered Rome's one indigenous literary genre. Very much an urban form, satire seeks to expose moral evil and political and social corruption through a mixture of poetic wit and savage indignation. Horace perfected the more witty variety; **Juvenal** (c. AD 60–140) the more savage. **Petronius** (first century AD), a friend of Nero, laced his satirical masterpiece (*Satyricon*) with a greater sexual effervescence. Satire, even when it is angry, is essentially comic in tone, not only because it induces laughter, but because it abandons the high diction of tragedy for a low or mixed style. Roman satire exerted a strong influence on such Enlightenment Age authors as Molière, Voltaire, Pope, and Swift. Horace's verse epistles, letters written in poetic form that take up social, political, and aesthetic issues of the day, also influenced the writers of the late seventeenth- and eighteenth-century Age of Reason—most notably, Alexander Pope, whose fellow poets were the central figures of England's Augustan Age.

Virgil, whose career, like that of Horace, was financed by Maecenas, the West's first great patron of the arts, began by writing pastorals in imitation of Theocritus and a Roman version of Hesiod's *Works and Days* known as the *Georgics*; but Augustus, eager to immortalize his reign through a Roman version of the

Iliad and the *Odyssey*, pushed the at-first reluctant poet to conceive and compose one of the greatest poems ever written: the *Aeneid*. While remaining faithful to the conventions of Homer, including the use of dactylic hexameter, which is far more difficult to write in Latin than in Greek, Virgil re-imagined the epic as a statement not only about human struggles but about the very movement and purpose of history. Inspired by such epic historians as Herodotus, Thucydides, and Livy, Virgil set out to construct an epic that, while set in the heroic past of Homer and the Greek tragedians, told the story of Rome's foreordained greatness. Despite its great length, the *Aeneid* displays in nearly every line the polished, self-conscious artistry of the Alexandrians. And the *Aeneid* proved, as the Greek tragedies had already suggested, that great literature can be a vehicle for the serious contemplation of philosophical, theological, political, and ethical ideas.

Ovid also composed a monumental epic that has endured (the *Metamorphoses*); however, whereas Virgil's is solemn, heroic, and devoid of humor, Ovid's is witty, robust, comic, and, at times, scandalous. Ovid began his career writing urbane, sophisticated erotic poetry in which he presents himself as a self-conscious satirical poet and self-confident rake who wants to write an epic like his hero, Virgil, but keeps being drafted by Cupid to celebrate love (rather like the filmmaker Woody Allen, who tried several times to make serious movies like those of his idol, Ingmar Bergmann, but kept coming back to his signature satirical-sexual comedies). Eventually, Ovid would settle down and write the *Metamorphoses* (in dactylic hexameter, no less), but it would be more of a **mock epic** in which he would imitate (in order to parody) such things as the battles of the *Iliad*, the adventures of the *Odyssey*, the excessive psychological realism of the tragedians, the sophistication of the Alexandrians, and the historical sweep of the *Aeneid*. In imitation of Hesiod's *Theogeny*, Ovid weaves together all the best mythological stories of gods and heroes, but he gives it (à la

Virgil) both a grand unifying theme (change from one form into another) and a touch of Roman propaganda (showing how all of time, whether mythical, legendary, or historical, culminates with the Roman Empire of Caesar Augustus). The *Metamorphoses* would prove to be the supreme sourcebook of mythology for the next fifteen hundred years and would leave its mark on such poets as Dante, Chaucer, and Shakespeare. It is also the great original of such mock epics as Pope's *The Rape of the Lock* and Byron's *Don Juan*.

MEDIEVAL

Date: 400–1500

Figures: Augustine, Boethius, Aquinas, Chrétien, Ariosto, Dante, Boccaccio, Chaucer, Malory

Genres: epic, romance, allegory, collections of tales, mystery plays, mixed genres

Theme: love of order and hierarchy

With the fall of the Roman Empire, the Classical Age of Greece and Rome gave way to the Medieval Age of European Catholic Christendom. The religious, political, and aesthetic culture of the Middle Ages was in great part a creation of **St. Augustine** (354–430), author of the Western world's first **autobiography**, *The Confessions*, who, in the early fifth century, fused together the classical heritage of Greece and Rome and the Judeo-Christian legacy of the Bible and the creeds. This joining of Athens and Jerusalem was further cemented by the widespread belief that the Christian God had used pre-Christian poets and philosophers such as Virgil and Plato to prepare the pagan world for the coming of Christ and the greater revelation of the Bible.

Given their love for heroic tales and adventures, for order and hierarchy, and for earthly and cosmic pageantry, it is no wonder that the Medievals gravitated toward the genre of epic. Still, aside

from the eighth-century epic of *Beowulf* (which, in any case, was inspired by Norse sagas rather than Greco-Roman epics), the "epics" of the Middle Ages more often fell into the genre of **romance**. Though romances share the length and sweep of the Classical epic, they are far more fanciful and episodic than the *Iliad*, the *Odyssey*, and the *Aeneid*. Generally focusing on either Charlemagne's paladins or King Arthur's knights, romances were concerned with issues of chivalry and loyalty. Though little read today, they were once read (or listened to) with great passion, and they actually did not reach their height of artistry until the sixteenth century. A list of influential romances would include the *Song of Roland* (eleventh century), **Wace**'s *Roman de Brut* (twelfth century), **Chrétien de Troyes**'s *Lancelot* and *Percival* (twelfth century), **Wolfram von Eschenbach**'s *Parzival* (c. 1200), **Marie de France**'s *Sir Launfal* (c. 1200), the anonymous *Sir Gawain and the Green Knight* (c. 1370), **Chaucer**'s *Troilus and Criseyde* (c. 1385), **Pulci**'s *Morgante Maggiore* (1483), **Boiardo**'s *Orlando Innamorato* (1494), **Ariosto**'s *Orlando Furioso* (c. 1500), and **Tasso**'s *Gerusalemme Liberata* (1581). The chronicles of the Crusades—such as **Villehardouin**'s *The Conquest of Constantinople* (c. 1210) and **Joinville**'s *The Life of Saint Louis* (1309)—offer a sort of historical prose counterpart to the verse romances. In a sense the two forms find their culmination in one of the masterpieces of English prose: **Sir Thomas Malory**'s *Le Morte d'Arthur* (c. 1469).

The finest and most highly polished of all the romances was **Edmund Spenser**'s *The Faerie Queene* (1590s), written in Spenserian stanzas. Spenser's epic work borrowed as well from another favorite medieval genre: the allegory. As discussed in chapter 1, allegories (such as *Pilgrim's Progress*) present internal struggles (emotional, intellectual, or spiritual) by expressing them through concrete, external characters and encounters. **Boethius**'s *Consolation of Philosophy* (c. 524), written on the cusp of the Classical and Medieval Ages, proved as influential as Ovid's *Metamorphoses*

and was often imitated for its form and consulted for its wisdom. *The Romance of the Rose* (thirteenth century), *The Pearl* (fourteenth century), *Piers Plowman* (fourteenth century), and a number of Chaucer's *Canterbury Tales* (1390s) all fall under the genre of allegory.

Speaking of Chaucer (c. 1343–1400), the medieval love of romance, chronicle, and allegory, which the Renaissance **Cervantes** would both celebrate and parody in *Don Quixote*, was matched by a love for collections of stories, the most famous of which are *Canterbury Tales* and **Boccaccio**'s *The Decameron* (1350s). The former, mostly written in an early form of the heroic couplet, begins with a sublime example of romance (*The Knight's Tale*) and then quickly "descends" into the bawdy and earthy tales of the Miller and the Reeve—a mixture of styles that identifies the *Canterbury Tales* as a comic, rather than a tragic or an epic, work. In addition to incorporating a mixture of styles and genres, Chaucer achieves a kind of comic realism by allowing each of his tale-tellers to speak in their own unique idiom (as Dickens and Twain would do in their novels and Robert Browning would do in his dramatic monologues). Though Chaucer, like **Dante**, was a believer, he does not judge his characters directly but takes the position of a bemused observer. In the general prologue, Chaucer tells us that we can skip any tales that we think will be too bawdy for our taste, but, of course, we cannot. We must take them all or not at all: the whole seething, indecorous grab-bag. We must take them as the true Christian must take the Scriptures, with Ecclesiastes and the Song of Solomon well intact.

Dante (1265–1321) called his great epic the *Comedy* (a later editor added the word "divine") not to deny that he was writing an epic, but to highlight two unique features of his three-part work: that it ends with reconciliation rather than death; that it is written in a mixed style that ranges from the scatological details of *Inferno* to the higher diction of *Purgatorio* to the almost ineffable

sublimity of *Paradiso*. In the *Comedy*, Dante incarnates the medieval love of balance and hierarchy by presenting his reader with a universe of perfect order and harmony in which everything—literally everything—has its assigned place. There is nothing haphazard or accidental in Dante's *Comedy*; form and content work together in intimate unison. The interlocking terza rima form he invented for his epic (*aba*, *bcb*, *cdc*, *ded*, etc.) pays continuous homage to the Trinity and the incarnation by its three-line tercets and by having the second rhyme of each tercet leave its place in the "trinity" to descend and become the dominant rhyme of the next tercet. Dante pays further tribute to the Trinity by arranging for each of the three parts of his *Comedy* to be composed of thirty-three cantos; by adding an introductory canto to *Inferno*, he further arranges for the total number of cantos to add up to the perfect number of one hundred.

Dante chose Virgil as his guide through hell and purgatory both because Dante was self-consciously composing the next great epic and because he, like his fellow Medievals, considered Virgil to be a proto-Christian. Like the *Aeneid*, the *Comedy* is a "composite" work, layered with allusions to and imitations of all the great literature that preceded it. Unlike many modern writers, Virgil and Dante understood that originality is not the be-all and end-all of creativity; indeed, their epics are, simultaneously, 100 percent derivative and 100 percent original. In imitation of Virgil, Dante incorporates into his epic a rich and complex view of history, but Dante goes his master one better. The subject matter of the *Comedy* takes in nothing less than God's universe and his universal plan. Like **St. Thomas Aquinas**'s *Summa Theologica* (c. 1270), the *Comedy* offers a synthesis of all theological and philosophical wisdom—some critics have gone so far as to describe the *Comedy* as the *Summa* set to rhyme! As the supreme poet and philosopher of the Middle Ages, Dante and Aquinas embodied their era's passion for organizing, systematizing, and codifying: not surprising,

since the Medievals not only worshiped a God of order, harmony, and balance but lived in a universe that reflected that order, harmony, and balance.

Just as Virgil worked his way up to the epic by writing shorter, more lyrical works, so Dante began his career as a poet of love songs (known as **canzone**) and **sonnets**. In doing so, he followed the lead of the French love poets, or **troubadours**, many of whom were patronized by Eleanor of Aquitaine (c. 1122–1204), later the wife of Henry II and mother of Richard the Lion Hearted. It was these love poets of the twelfth and thirteenth centuries who all but invented the ideal of courtly love and helped turn poetry toward the subject of romantic love between the sexes, though in the early troubadour songs the lady was usually inaccessible and the love was not physically consummated. In the lovely and delicate *La Vita Nuova*, Dante presents us with a number of finely crafted canzone and sonnets written in celebration of Beatrice, a girl he loves from afar and who comes (in the *Comedy*) to embody the highest love of all: God's love for man.

One final medieval genre that was particularly popular with the common people bridged the gap between the highly formalized tragedies of Greece and the looser, more realistic plays of the Renaissance. Based on stories taken from the Bible (the creation, the flood, the nativity, the passion, the second coming, and so forth), the **mystery plays** of the fourteenth and fifteenth centuries brought drama and poetry directly to the people. Laced with a heavy dose of comedy, wit, pratfalls, and sexual innuendo, the mystery plays gave the old stories of Scripture a contemporary garb that endeared them to the people. The plays were mounted by different guilds (bakers, carpenters, shipwrights, etc.) and were performed during religious festivals. The spirit of the English mystery plays, which reach their artistic climax in the fifteenth-century *Wakefield Cycle*, can still be felt in some of the more elaborate Christmas and Easter plays put on by large congregations. Closely

allied to the mystery plays were the slightly later **morality plays**, which were more allegorical in nature and took up more abstract themes such as mercy and truth. The best-known morality play to come out of England is *Everyman* (c. 1500).

RENAISSANCE

Date: 1400–1600

Figures: Petrarch, Machiavelli, Erasmus, More, Montaigne, Bacon, Cervantes, Sidney, Spenser, Marlowe, Shakespeare

Genres: sonnet sequence, essay, satire, tragedy, comedy, history, romance

Theme: rebirth of classical humanism

Oddly, the lifespan of the man who is hailed by many critics as the first Renaissance poet (and the first "Renaissance man") falls directly in between those of the two supreme medieval poets, Dante and Chaucer. **Petrarch** (1304–1374) wrote love sonnets, allegorical poems, and Latin treatises like his medieval contemporaries, but he infused them with a greater realism (the subject of his love sonnets, Laura, is less idealized and spiritualized than Dante's Beatrice) and a firmer critical spirit that would prove foundational to the rise of Renaissance humanism. Renaissance means "rebirth," and what was being reborn was the spirit of the classical world. Of course, the classical world had by no means been abandoned by the Medievals (both Aquinas and Dante considered Aristotle one of the supreme authorities), but the Renaissance turned the focus of Europe back toward human things and secular concerns.

Without abandoning the Christian God, the Renaissance avidly devoured the newly reacquired dialogues of Plato and sought to idealize man ("man is the measure of all things") in a way not seen since the days of ancient Greece and Rome. The Renaissance spirit is felt in the more realistic paintings and sculptures of **Leonardo**

da Vinci (1452–1519) and **Michelangelo** (1475–1564)—which boldly depicted the body as well as the soul, and in the realpolitik vision of **Machiavelli**'s *Prince* (1513, 1516)—which took a practical rather than ethical view of political science. It is felt as well in the scientific theories of **Galileo** (1564–1642) and **Francis Bacon** (1561–1626)—which were based on observation rather than ancient authority, and in the often scathing satire of **Erasmus**'s *Praise of Folly* (1509) and **Thomas More**'s *Utopia* (1516)—which was willing to question accepted wisdom and hold it up to critical scrutiny. In all these writers we catch a fearless inquisitive spirit that would remake man and his world. Though such advances came with great dangers (best summed up in the legend of Faust, who sells his soul to the Devil to acquire secret, occult knowledge), and though the Reformation spearheaded by **Luther** (1483–1546) ended up dividing Europe into Catholic and Protestant camps, the Renaissance spirit reinvigorated Europe. From Italy it spread to France—**Rabelais** (c. 1494–1553, who perfected **realistic prose** and gave it a touch of the grotesque) and **Montaigne** (1533–1592, who essentially invented the form of the **essay**, which form Bacon also helped to shape) and to Spain—Cervantes (1547–1616, whose *Don Quixote* is, arguably, the first **novel**)—and to England.

After Shakespeare, the great poet of the English Renaissance (also known as the **Elizabethan Age**, after Elizabeth I who reigned from 1558–1603) was Edmund Spenser (c. 1522–1599). Despite its self-consciously archaic language and its reliance on the medieval genres of romance and allegory, Spenser's *Faerie Queene* embodies a Renaissance view of the dignity of man and of the glory of England and her queen. With the breaking up of the unity of medieval Christendom, European nationalism slowly came to the fore, and, though this rising nationalism did help to foster wars between nations, it also helped inspire national poets to reach great heights of literary achievement. As a proud Englishmen and member of the Church of England, Spenser used his epic to praise

all that was best in the English character (as Virgil had praised the virtues of the fledgling Roman Empire in his *Aeneid*), but he also indulged an unfortunate vein of anti-Catholicism. Still, though Spenser's attacks on Rome mar his epic, they do not prevent it from celebrating the power of man's search for (Christian) salvation and (Classical) virtue.

In the tradition of Petrarch, Spenser also composed a series of eighty-eight sonnets, loosely linked together around a common theme: a genre known as the **sonnet sequence**. Spenser's sequence (the *Amoretti*) was preceded—and eclipsed—by **Sir Philip Sidney**'s *Astrophel and Stella* (1591), which itself was eclipsed by the later 154 *Sonnets of Shakespeare* (1609; a sequence whose autobiographical nature is still debated today). The Elizabethan Age produced a number of other fine sonneteers, including **Michael Drayton** (1563–1631), **Sir Walter Raleigh** (c. 1522–1618), **Sir Thomas Wyatt** (1503–1542), and the **Earl of Surrey** (1517–1547). The latter two actually lived during the reign of Elizabeth's father, Henry VIII, and helped shape lyrical poetry for the next two centuries. In addition to his influential sonnets, Sidney (1554–1586) also wrote a prose pastoral work (*Arcadia*) that helped establish the sonorous rhythms of Renaissance prose and an essay on literary criticism ("An Apology for Poetry") that has proven to be one of the most effective and enduring defenses of poetry.

Still, despite the power of its lyric poetry, the Elizabethan Age is best known today for its drama. Until Shakespeare came on the scene, England's greatest dramatist was **Christopher Marlowe** (1564–1593), a hot-tempered, irreverent old sinner who actually died in a barroom brawl at the tender age of twenty-nine! It was Marlowe who gave Elizabethan drama its power and its psychological insight into character. Marlowe's *Doctor Faustus*, *The Jew of Malta*, and *Tamburlaine the Great* all center on tragic heroes who embody the Renaissance desire to grasp at greatness and to surpass all human limits—and who pay the price for their overreaching. Though

generations of teachers and students have attempted, through a misunderstanding of Aristotle's *Poetics*, to locate **tragic flaws** in the heroes of Greek tragedy, it is really the heroes of Marlowe's (and Shakespeare's) tragedies who are brought down by such fatal flaws as pride, avarice, and lust. In addition to giving shape to the tragic heroes of the Renaissance, Marlowe also gave a more formal gift to subsequent British drama—he initiated and championed a strong but supple blank verse as the ideal poetic medium for expressing the thoughts and passions of his characters. It was a gift that his great successor, William Shakespeare, would borrow, develop, and perfect.

Aside from Homer, whose *Iliad* is tragic and martial, while his *Odyssey* is comic and domestic, **Shakespeare** (1564–1616) is one of the few writers to explore to the full both the tragic and the comic vision of life. In his **comedies**—from the simpler *Comedy of Errors* and *Taming of the Shrew* to the more complex *Much Ado About Nothing* and *As You Like It*, to the melancholy *Love's Labor's Lost* and the magical *Midsummer Night's Dream*—Shakespeare uses thwarted love, melodramatic scheming, mistaken identity, bawdy buffoonery, and a general air of topsy-turvy to break down barriers and achieve social, emotional, and psychological reconciliation. The typical Shakespeare comedy ends with at least two marriages, for marriage is a social-religious institution that promises harmony, reintegration, and new life.

In contrast to the democratizing, life-affirming ethos of the comedies, Shakespeare's **tragedies**, most notably, *Hamlet*, *Othello*, *Macbeth*, and *King Lear*, present us with a more aristocratic, heroic world that is burdened by a kind of existential despair that is as much classical-pagan-stoic as it is Christian. Throughout these plays, but especially in the blank-verse **soliloquies** (speeches in which one of the characters bares his soul before the audience), Shakespeare shows a depth of insight into human psychology that has never been matched. In keeping with the spirit of

the Renaissance, Shakespeare creates characters who reach too far and, in doing so, display both the nearly god-like glory of man and his capacity for beast-like baseness. "What a piece of work is a man," extols Hamlet, "how noble in reason, how infinite in faculty"—and then ends his paean to humanity by dismissing man as a "quintessence of dust."

That Shakespeare could so thoroughly have mastered the tragic and the comic is achievement enough, but he excelled as well in two further dramatic genres: the **history play** and the **romance**. In such history plays as *Richard II*, *Henry IV*, *Henry V*, and *Richard III*, Shakespeare, while celebrating the glory of his native England, demonstrates an almost Virgilian sense of the forces of history and of the characters who both channel those forces and are themselves channeled by them. In his Roman plays (*Julius Caesar*; *Antony and Cleopatra*; and *Coriolanus*), he even succeeds in uniting the genres of history play and tragedy. This mixing of genres is also evident in *Merchant of Venice* and *Measure for Measure*, which though essentially comic in scope take up deeper spiritual issues of justice and mercy, law and grace, and in his late romances (*The Tempest*; *The Winter's Tale*; *Cymbeline*; and *Pericles*), which almost defy categorization in their yoking of comedy and tragedy.

LATE RENAISSANCE

Date: 1603–1660

Figures: Jonson, Herrick, Donne, Herbert, Marvell, Browne, Bunyan, Milton

Genres: masque, metaphysical poetry, baroque prose, sonnets, epic

Theme: passionate thinking

When studying the English Renaissance, it is customary to break it up into two major phases: the Elizabethan Age and the late Renaissance or seventeenth century (which stretches from the ascension of James I in 1603 through the Puritan Revolution led

by Oliver Cromwell to the Restoration of Charles II in 1660). Were it not for Shakespeare, I would myself champion the seventeenth century as the greater epoch of expansion. In making this somewhat controversial claim, I turn for defense to T. S. Eliot, who himself championed the seventeenth century as a high point in British thought and literature: an age that achieved, for a few brief decades, the perfect fusion of intellect and emotion, reason and imagination, science and religion. After the late Renaissance, Eliot argued, a **"dissociation of sensibility"** set in that severed head from heart, logic from intuition—a split that produced first the overly rational eighteenth century (the Enlightenment) and then the overly emotional nineteenth century (Romanticism). Before this split, however, the major poets and prose writers ("men of letters") of Britain produced a remarkable body of work with the power to address the whole man.

In the **Cavalier poetry** of **Ben Jonson** (1573–1637), who also wrote successful Elizabethan dramas—most notably, *Volpone*—and perfected, with **Inigo Jones** (1573–1652), the genre of the **masque**: a lavish, special-effects-laden entertainment that combined poetry and song with visual spectacle, English lyric poetry achieves the same wit and polish as it had under the Roman Horace. This polished wit, together with a robust joy and humor, was carried on by the "Sons of Ben": **Thomas Carew** (c. 1595–1639), **Richard Lovelace** (1618–1658), **John Suckling** (c. 1609–1642), and especially **Robert Herrick** (1591–1674), who captured most perfectly the *carpe diem* ("seize the day") spirit of the Cavalier poets in his lyric, "To the Virgins, to Make Much of Time," written in ballad rhythm, but with an extra unstressed syllable in lines two and four (the "Greensleeves" stanza discussed in chapter 1).

The truly defining poetic voice of the seventeenth century, however (the one that so attracted Eliot), was to be heard in the **metaphysical poetry** of **John Donne** (1572–1631), who balanced some of the finest love and seduction poems ever written with a sequence

of **Holy Sonnets** that delve into the joys, struggles, and paradoxes of the Christian faith; **George Herbert** (1593–1633), whose quietly profound religious poetry, collected in *The Temple*, explores every nuance of the Anglican liturgy, the symbols of Scripture, and the demands of the religious call; **Andrew Marvell** (1621–1678), "To His Coy Mistress" and the superb "An Horatian Ode upon Cromwell's Return from Ireland"; **Richard Crashaw** (1613–1649), the most extreme of the metaphysicals in his sensual mysticism; and the young **John Milton** (1609–1674), "L'Allegro" and "Il Penseroso," "Lycidas," "On the Morning of Christ's Nativity," a number of excellent sonnets, and a masque, "Comus." In these poems, we encounter an exhilarating, thought-provoking wrestling match between body and soul, physical love and spiritual devotion, and the desires of the flesh and the ecstasies of the spirit. One of their main poetic devices was the **conceit**, which Eliot defines as "the elaboration (contrasted with the condensation) of a figure of speech to the furthest stage to which ingenuity can carry it."

According to Eliot, Donne, the most skilled and representative of the metaphysicals, was an intellectual poet who felt his thoughts "as immediately as the odor of a rose. A thought to Donne was an experience; it modified his sensibility. When a poet's mind is perfectly equipped for its work, it is constantly amalgamating disparate experience; the ordinary man's experience is chaotic, irregular, fragmentary. The latter falls in love, or reads Spinoza, and these two experiences have nothing to do with each other, or with the noises of the typewriter or the smell of cooking; in the mind of the poet these experiences are always forming new wholes." The metaphysicals were skilled at yoking together disparate thoughts and emotions, and this surprising and often jagged yoking spilled over into their prosody. Though metaphysical poetry always scans (usually in iambs), the meter is rougher and more heavily laden with substitutions than the smoother, more liquid lines of the Elizabethan lyric poets.

In keeping with the rougher eloquence of metaphysical poetry, the **baroque prose** of **John Donne**'s sermons and his *Devotions upon Emergent Occasions* (1624), **Richard Burton**'s *Anatomy of Melancholy* (1621), **Thomas Browne**'s *Religio Medici* (1643), **John Bunyan**'s *Pilgrim's Progress* (1678), and **John Milton**'s essays and tracts (especially "Areopagitica," 1644) gave to English letters a dramatic strength and power that made it as supple and surprising as verse. Incarnated in this baroque garb, the great "prose poems" of the seventeenth century were able to engage in vigorous dialogue over such issues as the immortality of the soul, the nature of melancholy, the "amphibian" status of man, the temptations of the spiritual life, and the freedom of the press.

In addition to his lyric poetry and baroque essays, Milton, the crowning poet of the late Renaissance, composed the only fully successful Greek tragedy in English: *Samson Agonistes* (1671), though T. S. Eliot's *Murder in the Cathedral* runs a fairly close second. He also composed (in blank verse) the only epic in English (or any other modern language) that can bear full comparison with the epics of Homer, Virgil, and Dante: *Paradise Lost* (1667). Though fully undergirded by classical humanistic learning, Milton's Protestant epic is far more austere and "Puritan" than the Catholic epic of Dante. *Paradise Lost* helped make the issue of **theodicy** (the attempt, to quote the poem, "to justify the ways of God to men") a central one in English poetry.

RESTORATION AND EIGHTEENTH CENTURY

Date: 1660–1789

Figures: Molière, Racine, Voltaire, Dryden, Pope, Swift, Johnson

Genres: tragedy, comedy, satire, verse epistle, mock epic, heroic couplet

Theme: reason and decorum

The late Renaissance was followed in England by a brief period know as the Restoration, which lasted from 1660 to the Glorious

Revolution of 1688, during which England cast off the rigors of Puritanism and turned toward the wit, satire, and general licentiousness of the French court of Louis XIV and its greatest comic dramatist, **Molière** (1622–1673) *Tartuffe*; *The Misanthrope*; *Don Juan*. In such naughty but genially humanistic **Restoration Comedies** as **William Wycherley**'s *The Country Wife* (1675) and **William Congreve**'s *The Way of the World* (1700), and in the politically and religiously savvy satires of **John Dryden** (1631–1700) *Absalom and Achitophel*; *MacFlecknoe*; *The Hind and the Panther*, English letters adapted a more artificial, self-conscious pose that was less grand than that of the Renaissance but more cultured and refined.

In his mastery of the heroic couplet, his off-and-on relationship as a court poet, his interest in literary criticism, and his positioning of himself in dialogue with the ancient poets of Rome, Dryden helped pave the way for the full flowering in England of an age known variously as the eighteenth century, the Enlightenment, the Age of Reason, The Neoclassical Age, and the Augustan Age—an age that was also strongly influenced by such French neoclassical satirists as **Boileau** (1636–1711), tragedians as **Racine** (1639–1699) and **Corneille** (1606–1684), and men of letters as **Voltaire** (1694–1778). All these writers influenced the work of England's three central eighteenth-century writers: **Alexander Pope** (1688–1744), **Jonathan Swift** (1667–1745), and **Samuel Johnson** (1709–1784).

The greatest developments of England's Augustan Age were in the genres of the **verse epistle** (Pope's *Essay on Man* and *Essay on Criticism*), the **mock epic** (Pope's *The Rape of the Lock* and *The Dunciad*), **satire** (Swift's *Gulliver's Travels*, *The Tale of the Tub*, *The Battle of the Books*, and "A Modest Proposal") and **moral and aesthetic criticism** (Johnson's *Rasselas*, *Lives of the Poets*, "Preface to Shakespeare," and, of course, his highly influential *Dictionary of the English Language*). Much of the spirit of the eighteenth century is captured in **James Boswell**'s *Life of Samuel Johnson* (1791) and in the urbane yet spirited **essays** of Johnson, **Joseph Addison**

(1672–1719), and **Richard Steele** (1672–1729), which appeared in such periodicals as *The Tatler*, *The Spectator*, and *The Rambler*. The height of the Augustan Age in England is generally associated with the reign of Queen Anne (1702–1714), though Johnson kept the neoclassical spirit alive until 1784.

ROMANTIC

Date: 1789–1837
Figures: Rousseau, Goethe, Blake, Wordsworth, Coleridge, Byron, Shelley, Keats, Emerson, Thoreau, Melville, Hawthorne, Twain, Dickinson, Whitman
Genres: autobiography, crisis poem, closet tragedy, novel
Theme: nature, imagination, and perception

As **Voltaire**'s diverse body of work (most notably, his **philosophical novel**, *Candide*) helped set the style for French and English neoclassicism, so the spirit and vision of the age that followed, Romanticism, was in great part set by the equally diverse writings of the chameleon **Rousseau** (1712–1778): *The Social Contract*, with its famous first line, "Man is born free, but is everywhere in chains," suggesting that man was by nature good and could chose his own social and political destiny; *Confessions*, the first modern autobiography, motivated not, like Augustine's *Confessions*, by the desire to praise God but to assert the absolute originality of its author; and *Emile*, which advocated a natural, rather than neoclassical, education. In Germany, **Goethe**'s novel *The Sorrows of Young Werthe*, the melancholy hero of which commits suicide, and his two-part "epic" tragedy, *Faust*, which carries the Renaissance Faust forward into the "modern" age, were also influential in setting the tone of Romanticism. Goethe (1749–1832), however, later reverted to a more neoclassical stance, leaving his fellow German Romantics to carry on the torch: the brothers **Grimm** (Jakob, 1785–1863; Wilhelm, 1786–1859), **Schiller** (1759–1805),

Novalis (1772–1801), **Hoffmann** (1776–1822), **Heine** (1797–1856), **Fichte** (1762–1814), **Schelling** (1775–1854), and the brothers **Schlegel** (August, 1767–1845; Friedrich, 1772–1829).

Though all these exerted their influence on British Romanticism, the defining event that made Romanticism possible was the French Revolution (1789) and its radical faith that a nation could be shaped and altered by the dreams and visions of its people. British Romantic poetry was founded on a similar belief that the objects and realities of our world, whether they be natural or human, are not fixed in stone but can be molded and transformed by the visionary eye of the poet. This key romantic notion—that things are as they are perceived, that the external world is, in part, a projection of the internal mood of the poet (a notion strongly influenced by the epistemology of **Edmund Burke**, 1727–1797, and **Immanuel Kant**, 1724–1804)—finds its fullest aesthetic expression in two collections of poetry: *Songs of Innocence and Experience* (1789, 1794) by **William Blake** (1757–1827) and *Lyrical Ballads* (1798) by **William Wordsworth** (1770–1850) and **Samuel Taylor Coleridge** (1772–1834). In the former work, the poet reveals how the same images and events can take on a different coloring, form, and reality when viewed through the eyes of innocence and experience. In the latter, the poets present both common, mundane objects with a freshness and a wonder that lends them an air of the mystical, and strange, supernatural events (Coleridge's *Rime of the Ancient Mariner*) with an emotional intensity and psychological truth that makes them seem real and natural.

In addition to playing with perception, the Romantic poets composed a number of highly personal lyric poems and odes in which they chart an internal movement from despair to hope, crisis to resolution—an emotional and psychological turn from feelings of dejection and isolation to a renewed and restored sense of oneness with nature and the self. Some of the finest poems in this genre (known as **crisis poems**) include Wordsworth's "Tintern

Abbey," "Intimations Ode," and "Resolution and Independence"; Coleridge's "Dejection: An Ode" and "France: An Ode"; **Percy Bysshe Shelley**'s (1792–1822) "Ode to the West Wind," "Stanzas Written in Dejection," and "To a Skylark"; and **John Keats**'s (1795–1821) "Ode to a Nightingale" and "Ode on a Grecian Urn." In one of the most ambitious poems of the decade, Wordsworth wrote an epic autobiography in blank verse (*The Prelude*) that charts on a grand scale the crisis that Wordsworth (and many of his fellow artists and thinkers) suffered after the French Revolution morphed into the Reign of Terror. Coleridge did the same in a prose autobiography that is also one of the key works of nineteenth-century literary criticism (*Biographia Literaria*).

Meanwhile, **Lord Byron** (1788–1824) invented a new type of hero (the **Byronic hero**), who was patterned after Faust, the over-achiever who commits a taboo sin or plucks forbidden fruit and comes to regret it, but was infused with an overly self-conscious angst that isolated him from the rest of humanity. His most successful creations in this vein are *Childe Harold's Pilgrimage*, in Spenserian stanzas, and *Manfred*, a **closet tragedy** that is, like Milton's *Samson Agonistes*, a drama meant to be read rather than performed. Ironically, Byron, the most extreme Romantic, ended his career by taking (like Goethe) an unexpected neoclassical turn; his crowning achievement was a **mock epic** in ottava rima (*Don Juan*) that actually parodied his own earlier Byronic heroes. Shelley also tried his hand at the Byronic hero in his own closet tragedy, *Prometheus Unbound* (a reworking of Aeschylus's *Prometheus Bound*), as did his wife, **Mary Shelley** (1797–1851), whose novel, *Frankenstein, or The Modern Prometheus* (1818) embodies all the elements of the Byronic hero. Other nineteenth-century Byronic heroes may be found in **Bram Stoker**'s *Dracula* (1897), **Oscar Wilde**'s *The Picture of Dorian Gray* (1891), **Emily Brontë**'s *Wuthering Heights* (1847), and **Robert Louis Stevenson**'s *The Strange Case of Dr. Jekyll and Mr. Hyde* (1886).

Romanticism eventually traveled to America, where it influenced Transcendentalist men of letters such as **Ralph Waldo Emerson** (1803–1882), *Essays*; and **Henry David Thoreau** (1817–1862), *Walden*; and symbolic novelists such as **Herman Melville** (1819–1891), *Moby-Dick*; *Billy Bud*; and **Nathanael Hawthorne** (1804–1864), *The Scarlet Letter*; "Young Goodman Brown." The influence of Romanticism can also be traced in the nostalgic, picaresque novels of **Mark Twain** (1835–1910), *Tom Sawyer*; *Huckleberry Finn*; the unorthodox, deceptively simple poems of **Emily Dickinson** (1830–1886), mostly written in ballad rhythm and more transcendentalist than Christian in their theology, and the experimental, free-verse poems of **Walt Whitman** (1819–1892), collected in the ever-expanding *Leaves of Grass*. Whitman's poems, as profound and sweeping as they are infuriatingly adolescent and self-indulgent, turn away, like the poems of Wordsworth, from the aristocracy to seek wisdom in nature, in experience, and in the lives of common laborers. A strong argument can be made that the best, most representative American literature of the last two centuries was inspired by Emerson's Wordsworthian 1837 address, "The American Scholar," in which he called on America to find her own indigenous voice, separate from that of Europe, and to look to nature and experience for inspiration.

The influence of Emerson may account for an odd fact about American literature. Though nineteenth- and early twentieth-century America boasted more believing Christians than Europe, though America's one true philosophical and theological genius (**Jonathan Edwards**, 1703–1758) was an orthodox believer, and though many of America's most popular works were written by Christians (*Uncle Tom's Cabin*, 1852; *Ben-Hur*, 1880), almost none of America's major authors affirmed the Nicene Creed. Indeed, I myself cannot identify a single major American author between Emerson and the Catholic novelist and short-story writer **Flannery O'Connor**, who confessed belief in the Trinity, the incarnation,

the atonement, and the resurrection. (T. S. Eliot could not accept orthodox Christianity until he forsook America and became British, Tory, and Anglo-Catholic.) Under major American authors, I include not only the writers listed above but such key figures as **Henry Adams** (1838–1918), *The Education of Henry Adams*; **William James** (1842–1910), *The Varieties of Religious Experience*; **Henry James** (1843–1916), *The Portrait of a Lady*; **Jack London** (1876–1916), *The Call of the Wild*; **William Faulkner** (1897–1962), *The Sound and the Fury*; **Ernest Hemingway** (1899–1961), *For Whom the Bell Tolls*; **F. Scott Fitzgerald** (1896–1940), *The Great Gatsby*; **John Steinbeck** (1902–1968), *The Grapes of Wrath*; **Edgar Allen Poe** (1809–1849), "The Cask of Amontillado"; "The Raven"; **Henry Wadsworth Longfellow** (1807–1882), *Evangeline*; **Wallace Stevens** (1879–1955), "Sunday Morning"; **William Carlos Williams** (1883–1963), *Paterson*; **Ezra Pound** (1885–1972), *Cantos*; and **Robert Frost** (1874–1963), "The Road Not Taken."

VICTORIAN

Date: 1837–1901

Figures: Tennyson, Browning, Arnold, Mill, Huxley, Newman, Carlyle, Ruskin, Brontës, Dickens

Genres: lyric, epic, dramatic monologue, essay, novel

Theme: progress

With the ascension of Queen Victoria, who ruled Britain from 1837 to 1901, England shifted from the Romantic to the Victorian Age. Whereas Romantic poets looked to nature and the country-side, celebrated the individual, and cast a backward glance to the past, the Victorians looked to the city, celebrated the group, and pressed forward toward the future. In place of the older values of the aristocracy, the Victorian Age oversaw the rise of the middle class, a vast increase in industrialization and trade, and a focus on such "family values" as honesty, thrift, hard work, and sexual

abstinence. Though the Victorian Age was an era of growth and excitement, rapid developments in science and industry propelled a number of important authors into a crisis of faith, during which they questioned the very meaning of existence. These developments culminated in the scientific theories of **Charles Darwin**'s *Origin of Species* (1859), the free market capitalism of **Adam Smith** (1729–1790), the utilitarianism of **James Mill** (1773–1836) and **Jeremy Bentham** (1748–1832), and the economic determinism of **David Ricardo** (1772–1823) and **Thomas Malthus** (1776–1834).

This crisis of faith was most fully embodied in an epic poem by **Alfred, Lord Tennyson** (1809–1892). *In Memoriam*, written not in blank verse but in tetrameter quatrains that rhyme *abba*, was inspired by the death of Tennyson's friend **Arthur Henry Hallam** in 1833 but soon swelled into an elegy for England's (and Europe's) lost age of faith and pastoral innocence. By the end of *In Memoriam*, Tennyson moves to a higher and more mature faith, as he does in "Locksley Hall," and, to a lesser extent, in his later blank-verse Arthurian epic, *Idylls of the King*. **Matthew Arnold** (1822–1888) was never quite able to achieve the same resolution in his own poignant crisis poems: "Dover Beach"; "Stanzas from the Grand Chartreuse"; "The Buried Life"; "Empedocles on Etna"; and "The Scholar Gypsy." Victorian England's third great poet, **Robert Browning** (1812–1889), chose a different path, overcoming his personal angst by losing himself (Shakespeare-like) in the colorful characters that populate his dramatic monologues, which include "My Last Duchess"; "The Bishop Orders His Tomb"; "Childe Roland"; "Fra Lippo Lippi"; "Andrea del Sarto"; "Caliban upon Setebos"; "An Epistle of Karshish"; "Cleon"; "Saul"; "Bishop Blougram's Apology"; and his brilliant but difficult blank-verse epic, *The Ring and the Book*. Like Shakespeare's soliloquies, **dramatic monologues** feature a first-person speaker who addresses us directly and intimately but who is not to be interpreted as a mouthpiece for the poet. In most cases, the speaker

is warped or perverse in some way; yet, despite the fact that we are repelled by his tortured thoughts, we are nevertheless drawn in by his overwhelming charisma. Tennyson was also a master of the dramatic monologue: "Ulysses"; "Tithonus"; "Saint Simeon Stylites."

Still, despite the genius of Tennyson's and Browning's poetry, the Victorian Age was in many ways an age of prose. The great Victorian sages, men of letters who wrote nonfiction essays, were widely read by the very middle-class businessman whom they so enjoyed criticizing. Their essays helped set the moral, ethical, political, social, religious, and aesthetic standards of their age. The major Victorian sages include **T. H. Huxley** (1825–1895), Darwin's "bulldog," who popularized the theory of evolution; **John Stuart Mill** (1806–1873), a utilitarian economist who championed liberty in all its forms and whose influential *Autobiography* recounted his own crisis of faith; **Cardinal Newman** (1801–1890), whose conversion to Catholicism, recorded in his *Apologia Pro Vita Sua*, shocked the nation; **John Ruskin** (1819–1900), England's supreme art critic for two generations; **Thomas Carlyle** (1795–1881), whose obscure but brilliant *Sartor Resartus* advocated a kind of secular spirituality that profoundly influenced American Transcendentalism; and **Matthew Arnold**, who, after abandoning poetry, turned to a kind of prophetic prose that offered up culture and the arts as a new religion for a world that had lost its faith.

The other prose voice of the Victorian Age was heard in an increasingly realistic and middle-class genre that would come to dominate modern literature: the **novel**. The English novel was born out of the eighteenth century in the work of **Daniel Defoe** (1660–1731), *Robinson Crusoe*; *Moll Flanders*; **Samuel Richardson** (1689–1761), *Pamela*; *Clarissa*; **Henry Fielding** (1707–1754), *Tom Jones*; and **Laurence Sterne** (1713–1768), *Tristram Shandy*. It was further developed by **Jane Austen** (1775–1817), *Pride and Prejudice*; *Sense and Sensibility*; *Emma*; **Charlotte Brontë** (1816–1855), *Jane*

Eyre; and Emily Brontë (1818–1848), *Wuthering Heights*; and then climaxed in the novels of the Victorian Age's most beloved writer, **Charles Dickens** (1812–1870), *Oliver Twist*; *A Christmas Carol*; *David Copperfield*; *Hard Times*; *A Tale of Two Cities*; *Great Expectations*; *Little Dorrit*; *Bleak House*; and many others. Though Dickens's novels consistently attack the exploitation of the poor and the dispossessed, they remain sentimentally optimistic, genially humanistic, and broadly Christian in scope. In contrast, later Victorian novelists would grow increasingly cynical and bitter toward Christianity in particular and human nature in general: **William Makepeace Thackeray**'s *Vanity Fair* (1848), **George Eliot**'s *Middlemarch* (1872), and **George Meredith**'s *The Egoist* (1879).

EARLY MODERN AND MODERN

Date: 1890s–1960

Figures: Flaubert, Zola, Hardy, Dostoevsky, Tolstoy, Chekhov, Ibsen, Shaw, Wilde, Beckett, Williams, Joyce, Wells, Orwell, Woolf, Kafka, Camus, Proust, Eliot, and Yeats

Genres: novel, drama, lyric

Theme: experimentation and disintegration

By the end of the century, the novel takes a dark, existential, if not indeed atheistic turn. In the grittily realistic, viciously antisentimental novels of such French writers as **Flaubert** (1821–1880), *Madame Bovary*; **Stendhal** (1783–1842), *The Red and the Black*; **Balzac** (1799–1850), *The Human Comedy*; and **Zola** (1840–1902), *Germinal*; *The Earth*; a Darwinian, deterministic ethos prevails in which man is robbed of free will and becomes ground down into the seasonal cycles of nature. The movement out of which these novels were born is known as **naturalism**. Naturalism later spread to America: **Stephen Crane** (1871–1900), *Maggie: A Girl of the Streets*; **Theodore Dreiser** (1871–1945), *An American Tragedy*; *Sister Carrie*;

and **Frank Norris** (1870–1902), *McTeague*; *The Octopus*. It also spread to England, where it found its supreme voice in the increasingly bleak and hopeless novels of **Thomas Hardy** (1840–1928), *Far from the Madding Crowd*; *The Return of the Native*; *The Mayor of Casterbridge*; *Tess of the D'Urbervilles*; and the truly grotesque *Jude the Obscure*. Hardy later transferred his naturalistic perspective into a series of finely honed lyrical poems that are far less taxing to read than the novels. They include "Neutral Tones"; "Hap"; "The Darkling Thrush"; "Channel Firing"; and "The Convergence of the Twain."

A counter voice to the naturalism of France, America, and England is heard in the great nineteenth-century novels of Russia, which are as harrowing and bleak in their use of realistic sociological detail as are those of Zola but maintain a dialogue with the spiritual realm and offer more freedom and dignity (even if it is a tragic dignity) to their agonized characters: **Dostoevsky's** (1821–1881) *Crime and Punishment* and *The Brothers Karamazov*; **Tolstoy's** (1828–1910) *War and Peace* and *Anna Karenina*; and **Turgenev's** (1818–1883) *Fathers and Sons*. A similar, if somewhat sadder, note is struck in the realistic plays of **Chekhov** (1860–1904), *The Seagull*; *Uncle Vanya*; *The Cherry Orchard*; and his Norwegian contemporary, **Henric Ibsen** (1828–1906), *A Doll's House*; *Hedda Gabbler*.

Chekhov and Ibsen are two of the playwrights responsible for spearheading innovations in drama and raising its sagging aesthetic reputation. In contrast to Shakespeare, their plays were written in a naturalistic prose, featured heroes who were not royal or "larger than life," and eliminated epic actions and finales. Further innovations in drama quickly followed. The Irish **George Bernard Shaw** (1856–1950), *Pygmalion*; *Major Barbara*; *Arms and the Man*, used his plays as tracts to make wider philosophical statements. **Oscar Wilde** (1854–1900), *Lady Windermere's Fan*; *The Importance of Being Earnest*, used his plays as a platform for social satire. **Samuel**

Beckett (1906–1989), *Waiting for Godot*; *Endgame*, integrated existentialism and the absurd into the drama. The German **Bertolt Brecht** (1898–1956), *Mother Courage and Her Children*; *The Life of Galileo*, tried to break down the wall between actors and audience. The Italian **Luigi Pirandello** (1867–1936), *Six Characters in Search of an Author,* broke the wall down even further. The American **Eugene O'Neill** (1888–1953), *Desire Under the Elms; Mourning Becomes Electra*, reinvigorated classical drama by replacing the gods with Freudian psychology. **Tennessee Williams** (1911–1983), *A Streetcar Named Desire*; *The Glass Menagerie*; *Cat on a Hot Tin Roof*, explored more fully the sexual desires and frustrations of his characters. **Arthur Miller** (1915–2005), *Death of a Salesman*, shocked the country by centering a high tragedy around a lower-middle-class hero.

Further experimentation in the novel also followed quickly. The Irish **James Joyce** (1882–1941), *A Portrait of the Artist as a Young Man*; *Ulysses*; *Finnegan's Wake*, fashioned a new kind of language for prose. The British **H. G. Wells** (1866–1946), *The Time Machine*; *The War of the Worlds*, not only birthed the serious science fiction novel but warned against the limits of scientific progress—a theme picked up in such dystopic novels as: **George Orwell**'s *1984* (1948); **Aldous Huxley**'s *Brave New World* (1932); **Yevgeny Zamyatin**'s *We* (1924). **Virginia Woolf** (*Mrs. Dalloway*; *To the Lighthouse*) along with Joyce and Faulkner, perfected the narrative technique of **stream of consciousness**, a technique that uses odd syntactical and associational patterns to capture the movement of the mind. **D. H. Lawrence** (1885–1930), *Sons and Lovers*; *Women in Love*, brought a frank Freudian treatment of sexuality into the novel. The Austrian **Franz Kafka** (1883–1924), "The Metamorphosis"; *The Trial*, incorporated into his stories a modern sense of paranoia and dehumanization. The French **Albert Camus** (1913–1960), *The Stranger*; *The Plague*, integrated existentialist philosophy into a compelling narrative, and **Marcel Proust**

(1871–1922), *Remembrance of Things Past*, modernized and intensified the Romantic obsession with memory. The German-American **Thomas Mann** (1875–1955), *Death in Venice*; *Mario and the Magician*, brought a tormented spirituality back into a genre dominated by the deterministic theories of **Darwin** (1809–1892), **Marx** (1818–1883), and **Freud** (1856–1939).

In poetry, the early twentieth century was dominated by the work of **T. S. Eliot** (1888–1965) and **William Butler Yeats** (1865–1939). In such poems as "The Love Song of J. Alfred Prufrock" and *The Wasteland*, a highly condensed, extremely self-conscious, obscurely allusive epic in early free verse that would have delighted the Alexandrians, Eliot captured to perfection early modern urban angst. Yeats, meanwhile, wrestled with the bourgeois-ification of his native Ireland ("September 1913"; "Easter 1916"), invented his own mystical, esoteric, mythological view of history ("Leda and the Swan"; "The Second Coming"), and reinvigorated the Romantic crisis poem for the early modern world ("The Wild Swans at Coole"; "Among School Children"; "Sailing to Byzantium").

RESURGENT CHRISTIAN VOICES

Although the Victorian Age was one of growing secularity, it produced a Christian thinker and writer of genius, Cardinal Newman, whose *Idea of a University* remains one of the most profound meditations on the integration of faith and learning and the unity of truth ever written. The mature, post-*David Copperfield* novels of Dickens, especially *Hard Times*; *Little Dorrit*; and *A Tale of Two Cities*, show a deepening understanding of Christ and of Christianity that, at least to my mind, moves beyond the expected sentimental piety of the age. Though Tennyson struggled mightily with the faith, his work too shows an increased desire to know Christ more fully and directly in an age of growing skepticism (see "Crossing the Bar"). Though most readers today, whether secular or Christian, are unaware of it, Browning matured into perhaps

the greatest Christian poet of the nineteenth century. Although the speakers of his early monologues are simple villains, the speakers of his later, lengthier, more complex monologues are quite different. As Browning matured as a poet and a believer, he began to perceive in even his most depraved speakers a seed of redemption, a spark of humanity that contained within it the real (if slight) possibility of emotional and spiritual regeneration.

Browning's wife, **Elizabeth Barrett Browning** (1806–1861) was a strong Christian poet. Her intensely moving sonnet cycle, *Sonnets from the Portuguese*, synthesizes romantic love and Christian faith and imagery in an unforgettable way. **Christina Rossetti** (1830–1894), sister of pre-Raphaelite poet and artist **Dante Gabriel Rossetti**, also had a strong faith. Her haunting *Goblin Market* deals with issues of temptation, sexuality, and lost innocence from a Christian perspective. **Gerard Manley Hopkins** (1844–1889), the finest, most innovative poet of the late Victorian Age—he invented a new, heavily accented meter that he called **sprung rhythm**—was a Jesuit priest. He wrestled in his poetry (*The Wreck of the Deutschland*; "The Windhover"; "Pied Beauty"; "Spring and Fall"; etc.) with the problem of pain (theodicy), the loss of belief in the modern world, and the glory of God. Two other nineteenth-century authors who deserve mention here are **Hans Christian Andersen** (1805–1875), a strong believer whose timeless fairy tales are rich with Christian themes and morals, and **Victor Hugo** (1802–1885), who, though he was likely heterodox in his personal beliefs, gifted the world with two of the most powerful Christian novels ever written: *The Hunchback of Notre Dame* and *Les Misérables*.

After his conversion and his move to England, Eliot matured into one of the greatest and most influential Christian poets since Donne. In his sublime "Journey of the Magi," which effortlessly fuses the autobiographical Romantic crisis poem with the dramatic monologue, Eliot charts his own movement from cynical modernist to believer. In *Murder in the Cathedral*, a verse tragedy

in the manner of classical Greece that substitutes the language of liturgy for the choral songs of Aeschylus and Sophocles, Eliot struggles with issues of worldly temptation and martyrdom. In *The Four Quartets* ("Burnt Norton"; "East Coker"; "The Dry Salvages"; and "Little Gidding," he takes up complex issues of time and eternity. Eliot was also one of the finest literary critics of the twentieth century. In addition to reviving the Christian poetry of John Donne and his fellow metaphysicals, Eliot meditated on the role of Christianity in modern culture (*The Idea of a Christian Society*; *Notes Towards the Definition of Culture*). Though they struggled mightily with faith and doubt and with their lifestyle choices, Oscar Wilde (1854–1900) and **W. H. Auden** (1907–1973) were also Christian poets who wrestled with issues of a deeply spiritual nature.

In prose, the most profound and complex wrestling with the Christian faith is to be found in the novels and short story collections of the southern Catholic writer Flannery O'Connor (1925– 1964): *Wise Blood*; *Everything That Rises Must Converge*; *A Good Man Is Hard to Find*. Very few writers have pursued with such vigor the aesthetic implications of the incarnation. Other Catholic novelists whose work is imbued with faith, but in a far more obscure way than in that of O'Connor, include **Evelyn Waugh** (1903–1966), *Brideshead Revisited*; **Graham Greene** (1904–1991), *The Power and the Glory*; and **Walker Percy** (1916–1990), *The Moviegoer*. The Russian Orthodox **Solzhenitsyn** (1918–2008), *One Day in the Life of Ivan Denisovich*, helped revive a type of intense meditation on faith that is reminiscent of Dostoevsky. The Protestant **John Updike** (1932–2009), *Rabbit* trilogy, apparently wrote from a position of faith, though it's harder to see this in his novels than in those of Waugh, Greene, and Percy. Other Christian voices have been heard in the essays of **Elton Trueblood** (1900–1994), **Thomas Merton** (1915–1986), **Wendell Berry** (b. 1934), and **Annie Dillard** (b. 1945); the fiction of **Frederick Buechner** (b. 1926) and **Madeleine**

L'Engle (1918–2007); and the poetry of **John Berryman** (1914–1972), **Richard Wilbur** (b. 1921; named poet laureate of America in 1987), the British **Sir John Betjeman** (1906–1984; named poet laureate in 1972), and the Polish **Czeslaw Milosz** (1911–2004).

Perhaps the most widely influential and enduring Christian works to come out of the twentieth century are the science fiction/fantasy novels of the Anglican **C. S. Lewis** (1898–1963): *The Chronicles of Narnia*; *Till We Have Faces*; *The Space Trilogy*: *Out of the Silent Planet*, *Perelandra*, and *That Hideous Strength*; and of the Catholic **J. R. R. Tolkien** (1892–1973): *The Hobbit*; *The Lord of the Rings*; *The Silmarillion*—all of which are undergirded by a Christian worldview and an orthodox (Augustinian and Thomistic) understanding of good and evil, virtue and vice, heroism and temptation. Lewis and Tolkien were deeply influenced by the at once moral and mythopoeic fairy tales of the late Victorian Scottish **George MacDonald** (1824–1905): *At the Back of the North Wind*; *The Princess and the Goblin*; "The Light Princess"; *Lilith*; *Phantastes*, and by the diverse writings of **G. K. Chesterton** (1873–1936), including apologetics (*Orthodoxy*; *The Everlasting Man*), novels (*The Man Who Was Thursday*), and moral detective fiction (*Father Brown*). Lewis and Tolkien were friends with two other Christian writers: **Dorothy Sayers** (1893–1957), who translated Dante, wrote apologetics, and composed a series of radio plays on the life of Christ: *The Man Born to Be King*, and **Charles Williams** (1886–1945), who wrote such mystical, spiritual warfare novels as *All Hallows' Eve* and *Descent into Hell*.

Lewis himself was the finest apologist of the twentieth century (*Mere Christianity*; *The Problem of Pain*; *Miracles*; *The Screwtape Letters*; *The Great Divorce*), a prodigious literary critic who helped to revive the reputation of the Christian Middle Ages (*The Allegory of Love*; *The Discarded Image*) and the Christian worldview of *Paradise Lost* (*A Preface to* Paradise Lost), and an advocate for Christian culture (*The Abolition of Man*; *God in*

the Dock). Though the two greatest Christians academics of the twentieth century (Eliot and Lewis) did not originally see eye-to-eye, partly because the more traditional Lewis did not care for the free-verse poetry of Eliot, they eventually learned to respect one another. Significantly, Lewis and Eliot were also united in a second way: they were both English professors who carried within their very bones the full Western Canon that I have laid out in this chapter. Their knowledge of the Great Books was not only learned; it was intimate, joyous, and life-changing. Together they have left a rich legacy for Christian students and teachers who yearn to integrate their faith with their learning and who would study the past to help them understand the present and the future.

✚ 4

THEORY AND CRITICISM

Thus far in this book, we have concerned ourselves with the *how* of literature (how traditional rhythm and rhyme "work" and how poets use allusions, connotations, and figurative language to convey their ideas) and with the *who*, *when*, and *where* (the major authors, works, and aesthetic periods). In discussing the various genres of literature (epic, tragedy, pastoral, dramatic monologue, and so forth), we have also considered, at least on a surface level, the *what* of literature. But the full *what* question goes far deeper than determining a poem's genre.

If someone were to ask me *what* I am, I could say that I am 5 feet, 10.5 inches tall, or that I have brown eyes, or that I am an American or an English professor or a father, but those answers, though important, would not reach to the core of what I am. At the deepest, most essential level, I am a creature made in the image of God, a two-into-one fusion of body and soul. But I cannot even stop there, for behind the deeper *what* question lurks an even deeper *why* question. According to the Westminster Shorter Catechism, the answer to that deeper *why* question (to the question, that is, of my ultimate purpose) is this: to glorify God and enjoy him forever.

To determine the *why* and the deeper *what* of poetry, we must move beyond generic categories to ask questions not only about poetry's essential nature and purpose but also about the essential nature and purpose of the poet:

- What is the ultimate source of poetry? Does it come from nature, or God, or inner emotions?

- Does poetry, as an ultimately fictional medium, draw us closer to or farther away from truth? Is poetry merely a string of lies, or is it a form of prophecy, or is it a vehicle for reaching eternal ideas?
- Is the poet an artisan working a craft or a divinely inspired genius? Is he more like a potter or a prophet, more like an engineer or a madman?
- Does poetry (and the poet) serve a useful function in society? Is it just a form of frivolous entertainment, or can it teach valuable lessons? Or can it do both at once?
- Is a poem a self-enclosed artifact, a little world unto itself, or does it have meaning only in relation to the poet, or God, or the world, or the audience?

The branch of aesthetics that asks questions like these is known, variously, as **literary criticism**, **literary theory**, or **critical theory**. It seeks to define the exact nature, status, and social function of the arts, and it generally does so in an interdisciplinary fashion that draws ideas, perspectives, and terminology from such fields as philosophy, theology, history, anthropology, and linguistics.

CLASSICAL THEORIES

Ironically, the critical-theoretical enterprise was born not out of a positive celebration of the glories of poetry but out of a negative critique and challenge laid down 2,400 years ago by the Western world's greatest and most influential philosopher, Plato. In the process of constructing his ideal state, Plato, in *Republic* (early fourth century BC), decides that, despite his personal love for Homer, it would be best for all if the poets, and the rhapsodes who recite the poetry, were kicked out of the Republic. In justifying his decision, Plato references his influential theory of the "Forms."

According to this theory, everything in our physical world of change and decay is but a pale copy (or imitation) of something in the perfect, unchanging spiritual realm. This holds true whether that thing is an object (a chair, a table, a tree) or an idea (love, beauty, truth). Whereas our world is filled with different types of

chairs and different definitions of love, all of these small "c" chairs and small "l" loves are imitations of a perfect, unchanging, universal Chair or Love that resides in the heavens. Plato calls these universals the "Forms." For Plato, the trouble with poetry is that when a poet describes a chair or writes a poem about love, he does not imitate (*mimesis* in Greek) the Form of the chair (Chair) or of love (Love), but the earthly imitation of this ideal Chair/Love. Poetry, therefore, as it imitates what is already an imitation, is twice removed from reality (the Forms); as such it is an unreliable source of truth and can only lead astray those who study it.

Plato argues further that poetry appeals to the weaker, irrational part of our soul, rather than to the stronger, more rational part. It does not make us better or more moral or draw us closer to philosophical truth; to the contrary, it excites our emotions by a sort of aesthetic contagion. In another of his dialogues (*Ion*), Plato even asserts that poets do not write, nor rhapsodes recite, by art or skill but by a kind of possession. Far from understanding rationally what they create, poets are carried away by an irrational, divine madness that passes down from the poet to the rhapsode to the audience in a manner analogous to the way a series of metal rings are held together by the magnetic force of a lodestone.

For these reasons, Plato chooses to kick out the poets, but he does not let the matter rest there. At the close of *Republic* X, Plato issues a provocative challenge to all those who disagree with his decision. He will allow the poets back into the republic, he promises, if someone can prove to him by means of some formal defense (written either in verse or prose) that poetry (1) has a useful function in a well-ordered state, and (2) does not deceive but rather enhances our knowledge of truth. It is no exaggeration to say that, at least until the modern period, Plato's challenge provided both the inspiration and the raison d'être for literary theory. Most of the great works of literary theory to come out of Europe were as much attempts to define poetry as to defend it from Plato. Indeed,

the first great work of literary theory—one that future ages have added to rather than "surpassed"—was written by Plato's very own pupil, Aristotle.

In his *Poetics* (c. 330), Aristotle lays down the criteria for creating and judging such poetic genres as epic and tragedy. At the core of Aristotle's aesthetic theory is a fundamentally different view of **mimesis** (imitation). Whereas Plato saw mimesis as taking us away from the Forms, Aristotle believed that the mimetic process—especially when used by a tragedian like Sophocles—drew us closer to the ideal. Great tragedians, Aristotle argued, did not slavishly copy the stories of heroes such as Oedipus or Ajax but perfected those stories by removing from them all that was random and haphazard. The best poets, while working through concrete words and images, seek to embody universal truths. Whereas history deals only with the particular, poetry deals with the general—not with what happened but with what might happen in a more perfect world where there is a necessary link between cause and effect, where the stable, meaningful laws of probability determine action, and where a higher sense of fate and purpose is felt to be present. As such, poetry provides our world of change and decay with a vehicle for reaching *toward* (not away from) the Forms, for touching that which is essential and eternal—that which endures.

Aristotle's *Poetics* also offers what appears to be an answer to Plato's charge that poetry arouses the irrational side of man. Aristotle, who was more realistic, pragmatic, and down to earth than Plato, understood that emotions such as pity and fear were essential parts of the human psyche, ones that could not simply be excluded. If this is the case, might not art, especially public drama, serve a therapeutic function? Might it not serve both to purge and to purify excessive emotions? According to the *Poetics*, an audience that witnesses (or even reads) a great tragedy by Sophocles experiences what Aristotle calls a **catharsis** (Greek for cleansing, purging, or purifying). Drawn into and through the crucible of

great art, the viewer or reader of *Oedipus the King* reaches a climax at which his emotions of pity and fear are purged and/or purified. Far from deluding or "de-rationalizing" us, the arts, by means of their cathartic power, make us stronger, wiser, and more mature: they cleanse away base and petty emotions as an enema purges the bowels; they try our emotions as gold is tried in the fire; they order our emotions (and ideas) by ripping away the veil and letting us peer, for a moment, into the eternal.

Though the *Poetics* offers the supreme classical response to Plato, two other influential works of literary theory from the Roman period are worth noting. In a witty verse epistle titled "Ars Poetica" (c. 13 BC; "The Art of Poetry"), Horace, following in the wake of Aristotle, lays down the rules of **decorum**, of the proper relationship or "fit" between poetic form and content; for example, tragedy should focus on high characters and comedy on low ones. Such rules helped lend dignity and authority to the poetic arts, deflecting criticisms of poetry as an undisciplined or anti-intellectual affair. Indeed, Horace praises the best poets as civilizers of humanity. Far from the Platonic poet who spreads irrationality, the Horatian poet helps to tame the beast within and to establish cities and laws. Finally, in answer to Plato, Horace insists that poetry has the power **to teach and to please** (*dulce et utile* in Latin)—that, in fact, it teaches *through* pleasing.

Meanwhile, an anonymous Greek literary critic of the first century AD, long thought to be named Longinus, wrote an essay, "On the Sublime," that took a different approach from that of Horace. Longinus locates the glory of poetry not in decorum but in its ability to produce the **sublime**: a type of elevated language that strikes its listeners or readers with the power of a thunderbolt, transporting them to a higher realm of experience that transcends time and space. Though Longinus defines the sublime as the "echo of a great soul," he also surveys the methods that poets use to produce the sublime. In other words, Longinus, in answer

to Plato's dismissal of the poet as irrationally possessed, presents the sublime as the product of *both* **genius** and **art**, both of divine inspiration and craftsman-like skill. But Longinus goes further than this; in an act of great bravado, he presents Plato himself as one of the greatest poets and masters of the sublime. And why is Plato such a master, Longinus asks? He was a master because he was himself possessed by the sublime spirit of Homer!

MEDIEVAL THEORIES

As we pass from the pagan Classical Age of Greece and Rome to the Catholic Middle Ages, new criticisms of poetry arise that parallel those of Plato. Though the dual concern that poetry is irrational and takes us away from the Forms persists, Christian theology, ethics, and aesthetics nuance those concerns in new and different ways. At the center of Christianity lie two things, Jesus Christ and the Holy Bible, that claim to be, respectively, the incarnate and written Word of God. Divine inspiration is clearly a good thing in Christianity, but how are we to define the difference between the inspired Bible and inspired poetry? Through Christ, truth came into the world once and for all, and through the Bible we are empowered to understand and follow that truth. Within the church, Christ's divine presence is mediated through the sacraments; accordingly, through participation in and meditation upon Word (the Bible) and sacrament (Christ), the believer can proceed upward toward a grasp of the truth (of Plato's Forms, which Augustine put in the mind of God). What then of poetry that is not specifically tied to Word or sacrament? If it does not lead us directly to God, does it therefore lead us astray? Does poetry pose a spiritual danger? Does it distract us from God and turn our focus toward earthly, perhaps even sinful, things? What of specifically pagan poetry? Does it stand in opposition to Christian truth, or can the two be reconciled? Christians worship an incarnate Christ, a flesh-and-blood man who yet embodied the full essence and

divinity of the invisible Father. Can poetry too effect an incarnation of divine and human, spiritual and physical? Or does it present us with a false incarnation that parodies and even perverts the incarnation?

Though there have always been Christians who have looked with deep suspicion upon the pagan classics, dismissing them as unprofitable at best and demonic at worst, the central tradition of the Middle Ages that runs through Augustine, Aquinas, and Dante understood that the God of the Bible used great pagan philosophers and poets such as Plato and Virgil to prepare the ancient world for the coming of Christ. They understood as well that the literary, poetic aspects of the Bible enhanced, rather than detracted from, its meaning. For Aquinas, and other great medieval thinkers, nearly every verse of Scripture contains not one but four separate levels of meaning: the **literal** (or historical), the **allegorical**, the **tropological** (or moral), and the **anagogical**. In a letter to one of his patrons, Dante, who used the fourfold reading of Scripture as one of the philosophical and aesthetic foundations of his *Comedy*, offers just such a reading of the following verse: "When Israel out of Egypt came." Taken literally, he writes, this verse refers to the exodus; allegorically, it signifies how Christ freed us from sin; tropologically, it describes the conversion of the soul from its bondage to sin to its new freedom in Christ; anagogically, it prophesies that final, glorious moment when the human soul will leave behind the body's long slavery to death and corruption and enter the true Promised Land of heaven.

The implications of Scripture's **polysemous** nature—that is, its ability to hold in suspension a multiple number of meanings—for literary theory, and especially for the defense of poetry, are quite stunning. I shall return to these implications at the end of this chapter; for now, suffice it to say that the fourfold nature of Scripture taught the Medievals that poetry need not function as a set of mirrors deflecting us, in a succession of imitations, from

truth, but can represent instead a many-runged ladder that leads upward from earth to heaven. When a medieval like Dante came upon a passage in Homer or Aeschylus or Virgil or Ovid that conflicted with his faith, he did not immediately reject it as demonic but attempted to read it allegorically—a method that more often than not empowered him to excavate deeper levels of meaning that touched on truths that foreshadowed the fuller revelation of Christ and the Bible.

RENAISSANCE THEORIES

In Renaissance defenses of poetry, we encounter a mixture of the more secular approach of Aristotle and Horace and the more spiritual approach of Aquinas and Dante. In the best of these defenses, "An Apology for Poetry" (1580s), Sidney the classical humanist, in imitation of Horace and Longinus, hails poetry as the great civilizer and law giver and Plato as the greatest of poets. And then Sidney the Christian poet and critic goes a step further. In antiquity, he argues, poets were seers, and verse was the language of prophecy. Indeed, it was only through poetry that David, in the Psalms, was able to express and embody the majesty and beauty of God. Like God, the poet is a *maker*; whereas all other arts take their cue from nature, only poetry has the power to transcend and even improve upon the natural world. Through that higher form of mimesis that Aristotle describes in the *Poetics*, the poet soars past nature to glimpse the Forms, the eternal ideas in the mind of God.

And as to the charge that poetry makes men immoral and turns them away from the path of virtue, Sidney answers it by combining Aristotle's argument that poetry is more philosophical than history with Horace's argument that poetry teaches and pleases. Unlike history, which is bound to recount a particular event just as it was, even if that event debases virtue and encourages vice, the poet is free to alter the particular and to present virtue and vice

not as they are but as they should be. By doing so, poetry inspires the soul both to scorn the vices of its villains and to imitate the noble and virtuous actions of its heroes. Granted, philosophy can do this too, but it does so in a manner that is too grave and austere to bring delight and thus leaves the soul cold and indifferent. As his supreme example of how poetic fiction can be a better aid to virtue than either history or philosophy, Sidney recounts the parable of the ewe lamb that Nathan the prophet used to convict David of his sin (2 Samuel 12).

Finally, Sidney addresses three critiques of poetry that are as likely to be leveled by legalistic-minded Christians as by pragmatic-minded businessmen: that it is unprofitable, that it lies, and that it leads to sin. In answer to the first, he reminds us that poetry is far more efficient than either history or philosophy at moving people to virtuous behavior. To the second, he offers an oft-quoted reply: poets never lie, for they never claim their poems to be the truth. And as for the third, it is the abuse of poetry, and not poetry itself, that entices to sin. Indeed, if we are to accept this third argument as just cause for expelling poetry, then we must also expel the Bible, for it has often been perverted into a source for heresy and sin.

ROMANTIC THEORIES

During the Enlightenment, great poet-critics like Dryden (*An Essay of Dramatic Poesy*, 1668) and Pope (*Essay on Criticism*, 1711) turned back to the classical rules of decorum laid down by Horace, leaving it to the more revolutionary Romantic poet-critics, Wordsworth ("Preface to *Lyrical Ballads*," 1800), Coleridge (*Biographia Literaria*, 1817), and Shelley ("A Defense of Poetry," 1821), to break new critical ground.

With an understated, almost naïve boldness, Wordsworth uses his "Preface" to redefine the nature and status of poetry. Rather than treat poetry as an imitation (mimesis) or as a vehicle

for teaching and pleasing, he treats it as though it were, first and foremost, a personal reflection of the poet's interactions with himself and his world. Though later poets would, in the name of Romanticism, reduce poetry further to a form of self-expression, Wordsworth himself was as committed as Aristotle or Sidney or Pope to using poetry as a vehicle for reaching after truth. The difference between Wordsworth and his predecessors is that he (like the American Walt Whitman) believed that the kinds of truths that are most essential and that most endure are found not in the city or court but in the countryside—in those very locales that a Horatian, decorum-centered poet considered fit only for comedy. Wordsworth further redefines the nature of the poet—not a craftsman or a teacher but a sensitive man in touch with his feelings—and the role of poetry—not so much to teach virtue as to bring people back in touch with themselves, with nature, and with beauty.

Coleridge, who was far better versed in philosophy, theology, and aesthetics than Wordsworth, identified in poetry, or, to be more specific, in **imagination**, which all the Romantics hailed as the origin of true poetry, an incarnational power that discerns and effects similitude in dissimilitude. He even coined a word, **esemplastic** (from three Greek words that mean "to shape into one"), to describe the imagination's power to fuse opposites into new wholes. To explain more fully the synthetic power of the imagination, Coleridge, in *Biographia Literaria*, distinguishes between what he calls the primary and secondary imagination. **Primary imagination** occurs when our individual consciousness is passively inspired by the absolute self-consciousness of God (the Great I Am)—an echo in the finite mind of the infinite. Though all Romantic poets, including Coleridge, yearned for such direct inspiration, Coleridge the critic nevertheless hails the **secondary imagination** as the true source of poetry. Whereas the primary imagination is passive, the secondary is active: it takes the raw material given it

by inspiration, breaks it down, and then reshapes it into new and vital forms. Coleridge calls these new forms **concrete universals**, for they fuse the particular with the general, and **organic wholes**, for each part of the poem functions within the whole like the organs of a living body. In contrast to the Medievals, Coleridge privileged symbol over allegory, for he felt the former came closer to the ideal of the organic whole. Nearly all poets and critics since have agreed with Coleridge.

Shelley's "Defense of Poetry," clearly meant to be a Romantic reworking of Sidney's "Apology," also hails imagination's power to fuse the two into one. In contrast to Pope and his fellow Neoclassicists, Shelley privileges imagination over reason, synthesis over analysis, intuition over logic, passive over active. For Shelley, the most extreme Romantic critic, no poet can actively will himself to write poetry; he can only await the breath of inspiration as a prophet must wait for the descent of the Holy Spirit. In contrast to Coleridge the critic, Shelley the critic hails the Romantic poet as a divine ventriloquist, a **poet-prophet** who receives direct inspiration from above and responds passively with a song or a poem—just as an **Aeolian** (or wind) **harp** trembles into song when the wind blows over its strings. Still, despite its passive nature, Shelley insists, like Sidney before him, that poetry is both a moral and a useful force. It is moral because it produces within us a sympathetic imagination that enables us to move out of ourselves toward others. It is useful for it allows us to synthesize and absorb (and thereby humanize) the overabundance of facts that the modern world has deluged us with.

EARLY MODERN THEORIES

Over the course of the second half of the nineteenth century and the first half of the twentieth, critics slowly turned away from the highly emotional and personal theories of the Romantics to look again at the poem itself. In "The Function of Criticism at the

Present Time" (1864), Matthew Arnold swings the critical pendulum from imagination and synthesis back to reason and analysis, from originality and creativity to hierarchy and tradition. In a famous phrase, he defines criticism as "a **disinterested** endeavor to learn and propagate the best that is known and thought in the world." Disinterested, as opposed to uninterested, signifies a critical approach that is removed, objective, and free from all political agendas. By "the best," Arnold refers to those very Great Books that have been the focus of this study. Indeed, Arnold helped to establish the Great Books (the Canon) as the foundation of a liberal arts education. Arnold firmly believed, as do I, that the works that make up the Canon are aesthetically superior and can be shown to be so by objective, disinterested criticism. In contrast, many critics since the 1960s have viewed the Canon as a product of sociopolitical forces that determine what is acceptable and what is not.

The next key figure in establishing the aesthetic, objective superiority of the Great Books was T. S. Eliot. In his essay "Tradition and the Individual Talent" (1919), Eliot argues that the greatest poets do not break with Europe's literary heritage but carry it inside them as a living tradition that is ever contemporaneous with their own historical moment. Such poets are conscious not only of the pastness of the past, but also of its presentness. They realize that their own poetry only has full value when it is viewed in the context of all the poetry that has come before. For that reason, Eliot concludes, they privilege "the mind of Europe" over their own individual minds.

Arnold and Eliot were followed in turn by an American school of criticism the key figures of which hailed mostly from the Deep South and tended to be both conservative and Christian in orientation. They include I. A. Richards (1893–1979), *Practical Criticism*; John Crowe Ransom (1888–1974), *The World's Body*; Cleanth Brooks (1906–1994), *The Well-Wrought Urn*; and W. K. Wimsatt

(1907–1975) and Monroe C. Beardsley (1915–1985), *The Verbal Icon*. Like the Romantics, the New Critics feared the growing corrosive influence of science and industrialism; however, unlike the former group, who sought refuge within the imagination of the sensitive poet, the New Critics sought to erect an aesthetic wall around poetry. Adopting a **formalist** approach to literature—one, that is, that privileges form over content—they treated the poem as a self-enclosed, self-referential artifact that obeyed its own laws. Over this timeless little world of words, the physical, historical forces of decay and change, not to mention the laws of science, could have no ultimate power or dominion.

In trying to unpack the rules of this aesthetic microcosm, the New Critics rejected any scientific (or, better, positivistic) view of language that would insist on a one-to-one correspondence between words (**signifiers**) and the meaning they point back to (**signifieds**). Instead, New Critics such as Brooks and Wimsatt celebrated poetry for its reliance upon allusion, connotation, figurative language, symbolism, and paradox. The job of the New Critic was not to extract out of great poetry a literal core of meaning or a didactic message but to take the poem *as it is*, with all of its ironies, ambiguities, and internal tensions intact. A poem is less like a mathematical proof, whose every step is subordinate to the solution, than it is like an arch, whose strength and stability are predicated upon the balance of opposing stresses.

Though most of the New Critics were also good poets, they were, more importantly, great teachers. It was the New Critics who taught the last several generations of undergraduates and professors how to **explicate** poetry: that is, how to perform a **close reading** of a poem. The goal of a close reading is not to eliminate, or *solve*, all the tensions in a poem, but to *resolve* each element of the poem into a fuller symphony, a richer counterpoint. Though the New Critics (along with Eliot) disparaged the Romantic poetry of Shelley and Byron, they were fans of the tighter, more controlled

odes of Keats and identified strongly with Keats's belief that a great poet possesses **negative capability**. According to one of Keats's letters, a poet who possesses negative capability (Shakespeare being the supreme example) is able to rest in the midst of mysteries and paradoxes without needing—philosophically or aesthetically—to reach after fixed answers or solutions.

It is terribly ironic that many critics since the 1960s have dismissed the New Critics as elitist, judgmental, and narrow-minded. True, they, like Arnold and Eliot, believed that a canonical body of literary works existed that was inherently superior and possessed essential, timeless value—but they did not "create" that Canon by some kind of patriarchal mandate. Nearly all the works of the Canon had long been accepted as superior; the New Critics merely provided a method and vocabulary to help explain *why* those works were felt to be worthy of preservation and study. If I may offer an analogy from the history of the church that has been misunderstood by champions of *The Da Vinci Code*: the Nicene Creed of the fourth century did not *create* doctrine out of thin air in order to support a patriarchal agenda but merely *confirmed* long-standing orthodox beliefs and provided a more exact terminology to explain them.

And let me please set the record straight on another thing. It was precisely those "elitist" New Critics who wrested control of literary theory away from an academic coterie of researchers with access to special collections and studies and put it in the hands of anyone with a critical mind, an eye for irony, and an Oxford English Dictionary. Unlike the postmodern theories that have arisen since the 1960s and are so obscure and jargon rich that only a small body of elite PhDs can understand and apply them, the theories and methods of the New Critics can be quickly taught, learned, and put into practice by graduates, undergraduates, and even advanced high schoolers. The true goal of the New Critics was, through hands-on training in the art of explication, to empower

and free students to interpret poetry on their own. Indeed, were it not for the democratizing legacy of the New Critics, I would not have written this book that you now hold in your hands!

POSTMODERN THEORIES

No, it is not the New Critics, I would argue, who have transformed the academy into an ivory tower; rather, it is the postmodern theorists, with their multicultural and relativistic agendas, who have cut the university off from the public at large, from the true goodness, truth, and beauty that lie stored in the Canon, and from common sense. Though a survey of the dozens of postmodern theories that have proliferated over the last half century lies beyond the scope of this book, I would like to conclude by briefly critiquing three postmodern critical movements that have, I believe, led astray the last three generations of teachers and students.

Critical Movement One: **historicism**. Although I have taken for granted in this book that great poets such as Shakespeare can transcend their historical moment and touch upon essential, enduring truths that are true for all people at all times, it must be admitted that a large percentage of academics deny this. Though Karl Marx has been discredited for two decades now, one of the foundational tenets of his materialist theories continues to influence the way literature is taught in our secular and even many of our Christian universities. Marx denied the possibility of transcendence, arguing that our religious teachings, our political ideologies, our aesthetic standards, and even our consciousness are products of the socioeconomic milieu into which we were born. The belief, cherished by the vast majority of readers, that Shakespeare's "genius" empowered him to rise above his age is dismissed by Marxists as a bourgeois illusion; Shakespeare was not a prophet tied to a transcendent source of inspiration but a product of Elizabethan power politics and economic structures. In the critical work of the New Historicists (and the many other postmodern schools that

share their views), both poet and poem are stripped of their ability to achieve a pure, disinterested, apolitical vantage point from which to view goodness, truth, and beauty. Indeed, historicists will generally treat the poet as the *least* likely source for clues as to what his poem means, for he is as much a product of his socioeconomic milieu as is his poem. (While writing my dissertation on Wordsworth, I was chided by a New Historicist professor for being so naïve as to offer a Wordsworthian reading of Wordsworth!)

Now, the New Historicists are, of course, quite correct to insist that students and teachers pay careful attention to the historical context of the poem and acknowledge that we are all influenced by our culture. Even in the case of the inspired Word of God, it is vital for preachers and parishioners alike to study the historical context of Paul's epistles. The problem with New Historicism comes when this helpful rule of thumb becomes a totalitarian fist. Like a hyper-Calvinist who reduces man to a puppet of predestination and thus robs him of his essential human nature—for if we do not possess any real freedom, then we are not truly made in the image of God—the New Historicist reduces man to a product of material and economic forces over which he has no control. The ironic thing is that, if historicism is correct, then there really is no reason to study the Great Books: if both they and we are nothing more than products of our socioeconomic milieu, then there is ultimately no way that we can communicate with each other. If historicism is true, then the multitudes of people who have discovered in Homer, Virgil, Dante, and Shakespeare truths of permanent value are deluded—as deluded as the billions of people across time and space who have, in defiance of the writings of the New Atheists, experienced the presence of God in their lives.

If historicism is correct, then no universal standards exist, and goodness, truth, and beauty are utterly relative. Critical judgment itself, once a cornerstone of literary theory, becomes impossible, for in the absence of universal standards, there can be no criteria,

and without criteria, there can be no judgment. And without the possibility of judgment, the entire liberal arts enterprise collapses, and the professor who has devoted his career to instilling in his students a refined aesthetic taste that can discern (and perhaps reproduce) true beauty is exposed as an idealistic stargazer.

Critical Movement Two: **feminism**. Readers who think that feminism means equal pay for equal work may be surprised that I list feminism as one of the major postmodern movements that has undermined literary theory. But I do not speak here of the (mostly) positive movement for equal economic, political, and educational rights for woman. I speak of feminism as it is pursued and taught in the academy, namely, as the belief that there are no essential differences between men and women, that masculinity and femininity do not represent real, eternal God-given natures but are merely social constructs. Though every honest, objective parent who has raised a boy and a girl will tell you that there *are* essential, "hard-wired" differences between boys and girls that are manifested almost from birth, the academy—and that includes many Christian academics in universities and seminaries—persists in asserting that it is only the forces of socialization (for example, we give boys toy trucks and girls dolls) that account for the observed differences between men and women. For the feminist, God did not create us male and female; it is, rather, society that programs us to behave in accordance with socially constructed male and female norms. It was the feminists who replaced the word *sex* with the word *gender*, not because the second word is more accurate but because the first word connotes an essential link between body and soul, biology and personality, that they reject.

Behind postmodern feminism lies a radically egalitarian agenda that would eliminate all differences and create a classless, colorless, sexless world. This androgynous vision has compromised the family structure and caused a generational identity crisis, leaving countless young people with a fractured sense of

their own God-given masculinity and femininity. And it has com-
promised as well the way we read and enjoy literature. Feminism
has prevented readers from engaging directly with the enduring
characters that greet us in the greatest epics, dramas, and novels.
Rather than study these characters as a way of gaining insight
into human nature and the ways that men and women interact,
the postmodern academy teaches its charges to stand in judgment
upon these characters and their authors and to uncover the struc-
tures (or **discourses**) of power that are the real determinants of their
thoughts, actions, and beliefs. Needless to say, most feminist and
New Historicist critics believe that they themselves are neverthe-
less able to rise above their own historical moment to see all things
past and present with an objective, critical eye.

As anti-essentialists, feminists reject all innate gender differ-
ences, a rejection that has found its way into the more general
postmodern rejection of all aesthetic distinctions between literary
genres. Just as feminists use the word *gender* to refer to the sexes,
so postmodernists use the word *text* to describe all forms of writ-
ing, from epic to tragedy to scripture to pulp fiction to TV sitcoms
to pornography. In the spirit of radical egalitarianism, postmod-
ernism refuses to privilege any one genre over another, preferring
to treat them all as cultural products with no separate aesthetic
existence. And that lands us back where we were with the New
Historicists, with a discredited Canon and with no set criteria to
judge it by.

Critical Movement Three: **deconstruction**. In the face of the
corrosive influence of science and industrialism, the New Critics
sought refuge in a microcosm of words. Perhaps, in the face of
the reductive theories of New Historicism and feminism that have
robbed the poet of his God-given freedom and sexual nature and
the poem of its transcendent status, traditional theorists could
return to the self-enclosed linguistic artifacts of Brooks, Wimsatt,
and Beardsley. Alas, such a simple return has been impeded by the

deconstructionist theories of Derrida and his heirs. Although the New Critics had conceded (and celebrated) the fact that the ironic structures of poetry make for a complex, ever-shifting relationship between signifiers and signifieds, deconstructionists have argued that the relationship between signifiers and signifieds is not ironic but arbitrary, that fixed linguistic meaning is as much a bourgeois illusion as the transcendent "genius" of Shakespeare or as the biblical assertion that not just our bodies but our souls are masculine and feminine.

According to Derrida and his heirs, whenever a reader or a traditional critic tries to trace a signifier back to its signified, he soon discovers that what he thought was a signified is really another signifier pointing to another signified, but when he gets to that signified, he finds that it too is another signifier, and so on. No matter how hard we try, we cannot find our way back to any type of original, or higher, or eternal Meaning. What that means for literary theory is that even *if* that higher, transcendent Meaning exists (which Derrida doubts), we can't reach it. As it turns out, Plato was partly right about poetry being twice removed from the Forms. He just didn't realize that poetry (*and philosophy*) is in actuality a hundred times removed from any form or center or origin that can be embodied in and communicated through the best that has been known and thought.

The Christian who reads this paragraph will realize, I hope, that if Derrida is right, not only is the meaningfulness of poetry rendered obsolete but the authority of Scripture is as well. If truth can neither be known nor communicated through words, then what is to become of a religion that is so strongly founded on the Word of God (the Bible)? The answer is that Christianity, unlike Islam, is not primarily founded upon a book but upon an incarnate Savior (the ultimate Word of God) who united and still unites within himself God and man, heaven and earth, the spiritual and the physical. The Christian should not be surprised that human

language is often slippery and that it takes dogged persistence to trace signifiers back to their signifieds. We are a broken people, and we live in a broken world—and we speak, so the Tower of Babel narrative tells us, a broken language. But when the Word became flesh and dwelt among us (John 1:14), that which was broken was mended. And since Christ is the eternal Word (or Logos), who was with the Father from the beginning (John 1:1), that mending both precedes and follows his incarnation and resurrection.

The Bible means because Christ means, and words mean because the Word became flesh and bridged the gap. But the Christian answer to deconstruction is even more glorious than that. As we saw when we looked at the medieval theorists, the language of Scripture is not linear and simplistic, yielding only a mathematical one-to-one correspondence, but richly polysemous, able to hold a number of simultaneous meanings in mystical suspension. The most effective Christian response to deconstruction is not a negative, rigid rejection of the "slippery," polysemous nature of language but a positive embrace of what I like to call "redemptive postmodernism." Rather than accept the postmodern claim that language is slippery and therefore meaningless, or fall back on the fundamentalist response that language is meaningful because it is not slippery, let us rather proclaim boldly that language is more meaningful precisely because it *is* slippery—because it can contain, incarnationally and sacramentally, the particular and the general, the imitation and the form, the signifier and the signified.

In Romans 9–11, Paul offers a complex dissertation on God's promises and plans for Israel, a multiple-point sermon, beloved of systematic theologians, that wrestles mightily with predestination and free will, justice and mercy, election and rejection. In verse after verse, Paul builds a doctrinal scaffold of carefully reasoned logic until he can go no further and loses himself in a liturgical poem:

Oh, the depth of the riches and wisdom and knowledge
 of God! How unsearchable are his judgments and how
 inscrutable his ways!
"For who has known the mind of the Lord,
 or who has been his counselor?"
"Or who has given a gift to him
 that he might be repaid?"
For from him and through him and to him are all things. To
 him be glory forever. Amen. (Rom. 11:33–36)

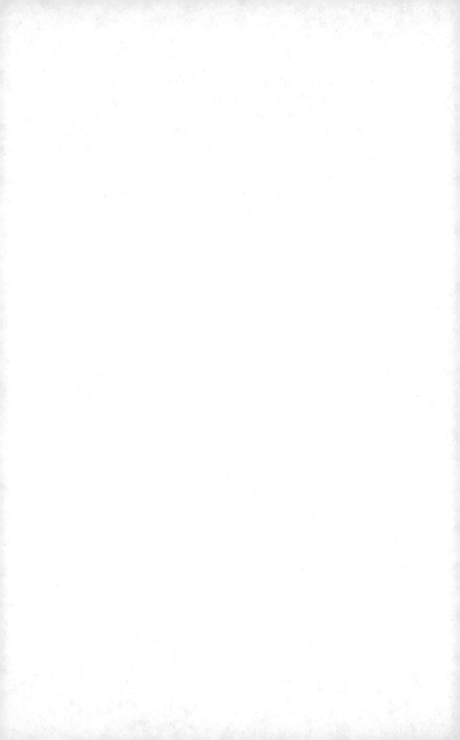

QUESTIONS FOR REFLECTION

1) What is lost when a poem is written in free verse rather than in a set meter or rhyme scheme? Does the presence or absence of meter or rhyme affect the way we read a poem? *Is* there a link between a poet's worldview and his use, or nonuse, of a set metrical scheme? Why was traditional meter abandoned in the twentieth century?

2) Do you find that the figurative language of poetry clarifies or confuses the point the poet is trying to make? Are there some ideas or feelings that can *only* be expressed through metaphors and similes? Why do religious poets, including David, the prophets, and John the Evangelist, rely so strongly on symbolism?

3) Have you ever experienced a catharsis while watching a play or reading a work of literature? How do you react when you read an ancient book such as the *Iliad* and feel a sudden kinship of understanding with one of the characters? Has your reading of great literature taught you that people vary greatly from age to age, or that human nature is essentially the same no matter the time or place?

4) Why do you think that Shakespeare is universally considered to be one of the, if not *the*, greatest poets of all time? Do you feel that you have come close to some kind of great and lasting truth when you read or watch a Shakespeare play?

5) Do you identify more with a romantic or a classical view of life? Do you prefer order, structure, and balance, or a kind of sublimity that shatters all forms? Have you ever read a poem in which you experienced a true union of the rational and the emotional, the logical and the intuitive?

6) Does the power to create great poetry belong only to an elite corps of geniuses, or can anyone create great poetry? Are great poets more like prophets or craftsmen? Can poets reach truths that transcend their historical moment? Do issues and ideas of permanent importance exist and can poetry embody them?

7) Does poetry serve any useful function in a scientific, technological age? Can a modern person really learn something of value from a book written one thousand years ago?

8) Should Christians devote time and energy to studying poetry written by pre-Christian poets who believed in many gods? What can a Christian learn of lasting value from Plato or Sophocles or Virgil?

TIMELINE

c. 720 BC	*Iliad* and *Odyssey* (Homer)
460–429 BC.	Periclean (Golden Age of) Athens
27 BC–AD 14	Reign of Caesar Augustus
1310s	Dante at work on *Comedy*
1390s	Chaucer at work on *Canterbury Tales*
1558–1603	Reign of Elizabeth I
1603–1660	Late Renaissance in England
1702–1714	Reign of Queen Anne
1726	*Gulliver's Travels* (Swift)
1789	French Revolution begins
1794	*Songs of Innocence and Experience* (Blake)
1798	*Lyrical Ballads* (Wordsworth and Coleridge)
1800	Second edition of *Lyrical Ballads* with Wordsworth's "Preface"
1821	Shelley writes "A Defense of Poetry"
1837–1901	Reign of Queen Victoria
1837	"The American Scholar" (Emerson)
1850	*In Memoriam*; Tennyson named poet laureate
1859	*Origin of Species* (Darwin)
1864	"The Function of Criticism at the Present Time" (Arnold)
1917	*Tradition and the Individual Talent* (Eliot)
1947	*The Well-Wrought Urn* (Brooks)
1966	Derrida lectures in America on deconstruction

GLOSSARY

Aeolian Harp: A small stringed instrument that produces music when the wind blows over its strings. In romantic theory and poetry, the Aeolian harp (named for Aeolus, the Greek god of the wind) is frequently used as a metaphor for the way in which inspiration blows over the poet and causes him to create.

Alexandrine: See Spenserian Stanza.

Allegory and Symbol: In an allegory, an abstract notion (like the inner struggle between good and evil) is translated into a picture language (the Devil on one shoulder, the angel on the other). There is no inherent link between the idea and the picture: one merely stands in for the other. In a symbol, however, the abstract notion (the salvific blood of Christ) is seen in and through the concrete, physical symbol (the communion wine). In the symbol, specific and general, temporal and eternal, concrete and universal meet and fuse in an almost mystical, incarnational way.

Alliterative Verse: Unlike the long (dactylic hexameter) line of Homer's epics, alliterative verse, made famous by *Beowulf*, consists of shorter lines bound together by alliteration (the repetition of initial consonants or vowels). Instead of being built on a set poetic foot, the alliterative line consists of four stresses, with great variation in terms of the number of syllables. The four-stress line is further broken into two halves, with a caesura at the center of each line.

Anagogical: See Four Levels of Meaning.

Anthropomorphism: See Personification.

Ballad Rhythm: A poetic form from the Middle Ages that was revived by the Romantics. It consists of four-line stanzas that rhyme *abab* (or *abcb*), with lines 1 and 3 written in iambic tetrameter and lines 2 and 4 written in iambic trimeter.

Blank Verse: A poetic form that consists of a series of unrhymed iambic pentameter lines. It is generally used to express heightened subject matter, such as Shakespeare's soliloquies and Milton's *Paradise Lost*.

Byronic Hero: An archetypal character who appears in many genres and in many guises (e.g., Adam, Satan, Prometheus, Faust, Frankenstein, Dracula, Heathcliff, Dorian Gray, Dr. Jekyll, Ahab). He is an overachiever who commits a taboo sin or plucks forbidden fruit and, as a result, is isolated from the rest of humanity.

Caesura: A pause or break in the rhythm of a line; the caesura tends to fall in the middle of a line, but a good poet will vary the placement of the caesura.

Canon: The Great Books of the Western world (those by Homer, Sophocles, Virgil, Dante, Shakespeare, and others) that have traditionally formed the core of humanistic studies.

Catharsis: In the *Poetics*, Aristotle argues that a well-constructed tragic plot will so move our feelings of pity and fear as to produce in us a catharsis of those emotions. The word *catharsis* may be translated in at least three ways: purgation, purification, or clarification.

Classical, Neoclassical, and Renaissance: Periclean Athens (fifth century BC) marks the birthplace of Western humanism, a time when the major thinkers, without abandoning a belief in the divine, put a greater focus on man as the measure of all things. The writers of the Golden Age of Athens explored man's potential and his limits and struggled with the paradox of fate and free will. They also invented and experimented with literary genres, leading to Aristotle's codification of the rules of decorum in the fourth century. During the Golden Age of Rome (27 BC–AD 14) and again in the eighteenth century, these rules of decorum were revived and adhered to; both of these ages bear the designation of "neoclassical." During the Renaissance (1400–1600), Greek humanism was reborn and man's potential and limits were again explored.

Close Reading: A method of explicating (or opening) a poem that was developed, taught, and propagated by the American New Critics.

Closet Tragedy: See Tragedy.

Comedy: See Tragedy

Conceit: One of the main poetic devices used by metaphysical poets. T. S. Eliot defines it as "the elaboration (contrasted with the condensation) of a figure of speech to the furthest stage to which ingenuity can carry it."

Crisis Poem: A highly personal lyric poem that charts an internal movement from despair to hope, crisis to resolution, dejection and isolation to a renewed and restored sense of oneness with nature and the self.

Deconstruction: A critical school (initiated by Derrida) that seeks to break down (or deconstruct) the traditional, essential link between words (signifiers) and the meaning that those words point back to (signifieds).

Decorum: The rules (established by Aristotle, Horace, and other classical and neoclassical theorists) that define the proper relationship between form and content. Poets who adhere to decorum prefer a serious, rational type of art that does not inappropriately mix the high and the low, the serious and the comic.

Disinterested: Disinterested, as opposed to uninterested, signifies an approach to criticism that is removed, objective, and free from all political agendas. The word was made famous in Matthew Arnold's definition of criticism as "a

disinterested endeavor to learn and propagate the best that is known and thought in the world."

Dissociation of Sensibility: According to T. S. Eliot, after the metaphysical poets, a dissociation set in that severed head from heart, logic from intuition, a split that produced first the overly rational Enlightenment and then the overly emotional Romantic movement.

Dramatic Monologue and Soliloquy: A lyric poem that features a first-person speaker who addresses us directly and intimately but who is not to be interpreted as a mouthpiece for the poet. The great soliloquies of Shakespeare, in which a character in a play steps forward and addresses the crowd directly, are precursors of the dramatic monologue.

Enjambment: An enjambment occurs when one line of poetry runs directly into the next without any punctuation at the end of the first line.

Epic, Mock Epic, and Romance: An epic is a long poem on a heroic subject that, despite its many digressions and repetitions, focuses on the internal and external struggles of a hero who has been chosen and set apart. A mock epic uses the same conventions as the epic but for the purpose of parody. Though romances share the length and sweep of the epic, they are far more fanciful and episodic and are generally concerned with issues of chivalry and loyalty. The designation "romance" is also used to describe plays that begin tragic and end comic.

Epochs of Expansion and Concentration: In "The Function of Criticism at the Present Time," Matthew Arnold makes a famous distinction between two epochs (or ages) in the life cycle of a culture. In epochs of expansion, a culture is rich with new and fresh ideas; during such epochs, poets are needed to harness this intellectual energy and convert it into great works of art. In epochs of concentration, ideas are stagnant and the free exchange of ideas is stifled; during such periods, critics are needed to inspire a new age of expansion.

Feminism: Though to most people, feminism merely signifies a belief that women should have full and equal access to the workplace, in the realm of postmodern theory, feminism means something quite different. It means the belief that there are no essential differences between men and women and that masculinity and femininity do not represent real, eternal God-given natures but are merely social constructs.

Forms: In the metaphysics of Plato, the Forms are a series of unchanging, transcendent ideas that exist (pure and invisible) in the heavens, and that serve as the patterns for all earthly, material realities.

Four Levels of Meaning: In the medieval church, nearly every verse of Scripture was believed to work on at least four separate levels of meaning: the literal (or historical), the allegorical, the tropological (or moral), and the anagogical. In a famous letter, Dante offers a fourfold reading of the verse: "When

Israel out of Egypt came." Taken literally, this verse refers to the exodus; allegorically, it signifies how Christ freed us from sin; tropologically, it describes the conversion of the soul from its bondage to sin to its new freedom in Christ; anagogically, it prophesies the moment when the human soul will leave behind the body's long slavery to death and corruption and enter the Promised Land of heaven. The four levels of meaning are not experienced one at a time or in ascending or descending order; rather, their nature is *polysemous* (Greek for "many signs"); that is, all levels of meaning are held simultaneously in suspension.

Free Verse: A poetic form that uses neither rhyme nor a standard meter. It has been the preferred form of poetry since the second half of the twentieth century.

Heroic Couplet: A poetic form consisting of a series of iambic pentameter lines that rhyme *aa*. Pope and Dryden are the masters of this form.

History: See Tragedy.

Humanism: Not to be confused with secular humanism, humanism is the belief that man is a free and rational creature, one who possesses innate dignity and value and whose life and achievements on this earth are of intrinsic and lasting worth. The humanist belief that "the proper study of man is man," far from being incompatible with Christianity, finds its firmest grounding in the Judeo-Christian view of man as made in the image of God.

Iambic Pentameter: One of the most common lines of English poetry, it consists of five iambs strung together. It is used most frequently in sonnets, Spenserian stanzas, and blank verse.

In Medias Res: In order to produce unified (rather than episodic) plots, Aristotle favored a device by which tragedians would begin their play not at the beginning but *in medias res* ("in the middle of things"), at a moment of tension and conflict. Epic poets from Homer to Milton have also preferred to plunge *in medias res* rather than to begin *ab ovo* ("from the egg"). Though it is Horace who really coined the term, Aristotle describes the device in his *Poetics*.

Literary Theory: The attempt to define the exact nature, status, and social function of both the arts and the artist.

Masculine and Feminine Rhyme: Masculine rhymes—which are often, though not always, monosyllabic—are those in which the rhyme ends firmly with a stress (FLY/DIE, SING/BRING, LET/for-GET, a-DORE/de-PLORE). In feminine rhymes—where the words *must* be at least two syllables long—the stress is followed by one or two unstressed syllables (FLY-ing/DY-ing, SING-ing/BRING-ing, LET-ing/for-GET-ing, a-DOR-a-ble/de-PLOR-a-ble).

Masque: A lavish, special-effects-laden entertainment that combines poetry and song with visual spectacle; it was intended both to flatter monarchs and to inspire them to virtue.

Metaphor: See Simile.

Metaphysical Poetry: A type of lyric poetry written in the seventeenth century that fuses intense, even passionate emotion with rigorous thought. In the work of metaphysical poets such as John Donne, we encounter an exhilarating wrestling match between body and soul, physical love and spiritual devotion, the desires of the flesh and the ecstasies of the spirit.

Metonymy: See Synecdoche.

Mimesis: Greek for "imitation," mimesis carries very different connotations in the writings of Plato and Aristotle. For Plato, mimesis refers to the fact that works of art are but imitations (or shadowy copies) of the Forms. In contrast, Aristotle saw the mimetic process of art as one that improves on and perfects existing ideas rather than weakening and obscuring them. For Aristotle the mimesis of a story yields a plot. Whereas the story of Oedipus concerns all those events that took place from his birth to his death, the plot of *Oedipus the King* focuses on a single day in the life of Oedipus when all the loose strands of his life come together in a climax of great power.

Mock Epic: See Epic.

Mystery Play: A late medieval form of drama, popular with the common people, that retells stories from the Bible in a contemporary manner laced with wit, pratfalls, and sexual innuendo.

Naturalism: A literary movement, most fully felt in the novel, that embodies a Darwinian, deterministic ethos in which man is robbed of free will and becomes ground down into the seasonal cycles of nature.

Negative Capability: According to John Keats, a poet who possesses negative capability (Shakespeare being the supreme example) is able (1) to enter into the lives of other beings and see the world from their perspective, and (2) to rest in the midst of mysteries and paradoxes without needing to reach after fixed answers or resolutions.

Neoclassical: See Classical.

New Historicism: A postmodern critical school that has been strongly influenced by Marx's belief that our religious teachings, our political ideologies, our aesthetic standards, and even our consciousness are products of the socio-economic milieu into which we were born. New Historicism asserts that art, far from transcending historical-political-social-economic realities, can be understood only as a product of such realities.

Objective Correlative: According to T. S. Eliot, an objective correlative is an external object, situation, or chain of events that parallels (correlates to) an internal emotion. As emotions cannot be perceived by the senses, the poet uses these physical objects and situations to externalize and concretize an internal or abstract emotion.

Ottava Rima: A poetic form from Italy, used most famously in Byron's *Don Juan*, that is made up of eight iambic pentameter lines that rhyme *abababcc*.

Pastoral and Pastoral Elegy: A lyric poem that celebrates the life of the countryside and evokes a nostalgic sense of loss for the simple life. The pastoral elegy combines mourning for a lost person, often a poet, with mourning for a lost way of life.

Personification and Anthropomorphism: Two types of metaphors. In the first, human or animal qualities are given to natural or inanimate objects; in the second, human characteristics are given to animals.

Polysemous: See Four Levels of Meaning.

Primary and Secondary Imagination: A distinction posited by Romantic critic Coleridge. The primary imagination occurs when the poet's individual consciousness is passively inspired by the absolute self-consciousness of God; the secondary imagination, on the other hand, takes the raw material given it by inspiration, breaks it down, and then reshapes it into new and vital forms.

Renaissance: See Classical.

Rhyme Royal: A poetic form, used most famously in Chaucer's *Troilus and Criseyde*, that is made up of seven iambic pentameter lines that rhyme *ababbcc*.

Romance: See Epic.

Romanticism: A movement born out of the French Revolution that, in contrast to the eighteenth-century Age of Reason, privileged imagination over reason, intuition over logic, energy over decorum, and the countryside over the city. The Romantics also emphasized the power of perception to alter nature.

Satire: An urban form developed in Rome, satire seeks to expose moral evil and political and social corruption through a mixture of poetic wit and savage indignation.

Simile and Metaphor: Though both of these terms connote a type of figurative language in which one thing is compared to another, the second is more magical. In simile, X is merely *like* Y; in metaphor, the poetic image almost fuses with the object it is compared to: X *is* Y.

Soliloquy: See Dramatic Monologue.

Sonnet: A highly condensed poetic form consisting of fourteen lines of iambic pentameter. Petrarchan (Italian) sonnets are broken into an octave (*abbaabba*) and a sestet (varies: *cdecde, cdcdcd, cddcee*, etc.). Shakespearean (Elizabethan; English) sonnets are broken into three quatrains (*abab, cdcd, efef*) and a closing couplet (*ee*). Sonnets can be written either as stand-alone poems or as part of a sonnet sequence.

Spenserian Stanza: A poetic form invented by Spenser for his *Faerie Queene* that consists of a series of nine-line stanzas rhymed *ababbcbcc*; lines 1–8 are written in iambic pentameter and line 9 is written in iambic hexameter (a poetic line also known as an alexandrine).

Stream of Consciousness: A literary technique, used by poets and prose writers alike, that employs odd syntactical and associational patterns to capture the movement of the mind.

Sublime: A type of elevated language or imagery that strikes its readers with the power of a thunderbolt, transporting them to a higher realm of experience that transcends time and space; the sublime, a product of both genius and art, is often contrasted with the beautiful.

Symbol: See Allegory.

Synecdoche and Metonymy: Two types of metaphors (X is Y). In the first, the whole is replaced by the part or the part by the whole ("Give us this day our daily bread"); in the second, one thing is replaced by something else closely related to it ("The White House said today . . . ").

Terza Rima: An Italian poetic form, invented by Dante for his *Divine Comedy*, that is made up of a series of tercets (three-line stanzas) that rhyme *aba*, *bcb*, *cdc*, etc.

Tragedy, Comedy, and History: Three subgenres of the drama. The first focuses on aristocratic characters, deals with heightened subject matter, and ends with one or more deaths; the second focuses on low and rustic characters, deals with social concerns, and ends with one or more marriages; the third deals with royal figures and is closer in spirit to tragedy than comedy. A closet tragedy is a drama meant to be read rather than performed. In the modern tragedies initiated by Chekhov and Ibsen, the hero comes from the middle or lower class (rather than from the aristocracy), and the language and subject matter are less heightened and more realistic.

Tragic Flaw: In the *Poetics*, Aristotle describes the proper tragic hero as a good man whose downfall is brought about "not by vice or depravity, but by some error" (*hamartia*). Aristotle makes it clear that this "tragic [or fatal] flaw" is not a vice, yet most readers tend to think of it as such. Our tendency to do so has been influenced by Shakespearean drama, where the tragic heroes tend to suffer from a specific vice: Macbeth's avarice, Othello's jealousy, Antony's lust.

Tropological: See Four Levels of Meaning.

Verse Epistle: A letter written in poetic form that takes up social, political, and aesthetic issues of the day. It was popular in Rome and was revived in the eighteenth century.

Victorianism: A movement that, in contrast to the previous Romantic Age, privileged the group over the individual, the future over the past, the city over the country, the rising middle class over the fading aristocracy, and progress toward utopia over a pastoral return to Eden.

RESOURCES FOR FURTHER STUDY

CHAPTERS 1 AND 2

The standard guide to unpacking rhythm and rhyme remains Paul Fussell's *Poetic Meter and Poetic Form*, revised edition (New York: McGraw-Hill, 1979). A second guide that is as witty as it is informative is John Hollander's *Rhyme's Reason: A Guide to English Verse* (New Haven, CT: Yale University Press, 2001).

The best one-volume handbook of literary terms available is M. H. Abrams's *A Glossary of Literary Terms*, 10th edition (Boston: Wadsworth, 2008). This book is particularly valuable for the student, for it also lists terms (and jargon) used by critical theorists and explains the assumptions, frameworks, agendas, and methods of each of the major critical schools. Another standard glossary that offers full chapters on each theoretical school is Wilfrid L.Guerin's *A Handbook of Critical Approaches to Literature*, 5th edition (Oxford: Oxford University Press, 2004). A third handbook that not only defines terms and periods but also offers biographies, synopses, and overviews of major authors, works, and periods is the indispensible *Benet's Reader's Encyclopedia*, 5th edition (New York: Collins, 2008). Yes, Oxford and Cambridge have encyclopedias like this one, but Benet's, to my mind at least, is superior to both.

CHAPTER 3

Anyone who wants a comprehensive understanding of European literature in general and British literature in particular must have on their shelves *The Norton Anthology of Western Literature I and II* (formerly known as *The Norton Anthology of World Masterpieces I and II*) and *The Norton Anthology of British Literature I and II* (New York: Norton). Both collections are available in numerous editions; I personally prefer the older editions since they are less compromised by political correctness and multiculturalism). A number of other publishers have put out such anthologies, but I still prefer the Norton, as the layout and the footnotes are the most user-friendly. Speaking of Norton, I would encourage students to purchase volumes from The Norton Critical Edition series. The editors devote the first half of each volume to an authoritative, well-annotated edition either of a single classic work or a selection of poems from a single poet, and the second half to a dozen or so essays written by various critics from various time periods and schools. Each book

in the series also offers an extensive bibliography. Some editions that students might find helpful include: *The Odyssey*, *Oedipus Tyrannus*, *The Canterbury Tales*, *Don Quixote*, *Hamlet*, *Paradise Lost*, *Gulliver's Travels*, *The Prelude*, *Frankenstein*, and those that cover the poetry of Spenser, Donne, Herbert, Blake, Shelley, Tennyson, and Browning.

For the best, most accessible overview of Greco-Roman mythology and of the legacy of Greece and Rome, consult three works by Edith Hamilton: *Mythology* (Boston: Back Bay Books, 1998), *The Greek Way* (New York: Norton, 1993), and *The Roman Way* (New York: Norton, 1993). Other excellent sources for all things Greek and Roman are the numerous books by Michael Grant. Two of the most helpful are *Myths of the Greeks and Romans* (New York: Plume, 1995) and *The World of Rome* (New York: Plume, 1987). Thomas Cahill's *Sailing the Wine-Dark Sea: Why the Greeks Matter* (New York: Doubleday, 2003) offers a highly readable assessment of what we owe to the Greeks.

Two surveys of ancient literature written from a Christian perspective are Peter J. Leithart's *Heroes of the City of Man: A Christian Guide to Select Ancient Literature* (Moscow, ID: Canon Press, 1999), and my own *From Achilles to Christ: Why Christians Should Read the Pagan Classics* (Downers Grove, IL: InterVarsity, 2007). My book offers close readings of the *Iliad*, the *Odyssey*, the *Aeneid*, and the major Greek tragedies.

To understand the ordered and balanced cosmos that lies behind so much of the best medieval and renaissance poetry consult C. S. Lewis's *The Discarded Image* (Cambridge: Cambridge University Press, 1994) and E. M. W. Tillyard's *The Elizabethan World Picture* (New York: Vintage, 1959). I discuss the ordered cosmos at some length in chapter 3 of my *Lewis Agonistes: How C. S. Lewis Can Train Us to Wrestle with the Modern and Postmodern World* (Nashville: Broadman, 2003). C. S. Lewis's *The Allegory of Love* (Oxford: Oxford University Press, 1985) and *A Preface to* Paradise Lost (Oxford: Oxford University Press, 1961) are still two of the best studies of medieval allegory and Milton's epic; the second also offers an analysis of the epic genre.

I consider the finest study of romantic poetry to be M. H. Abrams's *Natural Supernaturalism: Tradition and Revolution in Romantic Literature* (New York: Norton, 1973). I offer my own survey and analysis of the poetry of Blake, Wordsworth, Coleridge, Byron, Shelley, and Keats in my *Eye of the Beholder: How to See the World like a Romantic Poet* (Hamden, CT: Winged Lion Press, 2011). I have also published a study of the poetry of Alfred, Lord Tennyson and the prose writings of Huxley, Newman, Mill, Carlyle, Ruskin, and Arnold in *Pressing Forward: Alfred, Lord Tennyson and the Victorian Age* (Naples, FL: Sapientia, 2007).

Some other books of interest include Erich Auerbach's *Mimesis: The*

Representation of Reality in Western Literature (Princeton: Princeton University Press, 2003), which surveys the development of Western literature and focuses more on prose than poetry, and Allan Bloom's *The Closing of the American Mind* (New York: Touchstone, 1988), E. D. Hirsch Jr.'s *Cultural Literacy* (New York: Vintage, 1988), Harold Bloom's *The Western Canon* (New York: Riverhead, 1995), and C. S. Lewis's *The Abolition of Man* (San Francisco: HarperOne, 2001), each of which, in its own idiosyncratic way, defends the traditional literary canon.

CHAPTER 4

Many academic presses have published anthologies of literary criticism. For my money, the best single volume is Hazard Adams and Leroy Searle's *Critical Theory Since Plato*, 3rd edition (East Windsor, CT: Wadsworth, 2004). Two other excellent anthologies are Walter Jackson Bate's *Criticism: The Major Texts* (New York: Wolf Den Books, 2002) and Charles Kaplan and William Davis Anderson's *Criticism: The Major Statements*, 4th edition (New York: St. Martin's Press, 1999).

After Abrams's *Glossary of Literary Terms* and Guerin's *A Handbook of Critical Approaches to Literature*, the third best handbook of literary theory is David Daiches's *Critical Approaches to Literature* (Whitefish, MT: Kessinger, 2009). One of the most accessible overviews of literary theory, that, despite being written by a Marxist, is quite balanced, is Terry Eagleton's *Literary Theory: An Introduction*, 3rd edition (Minneapolis: University of Minnesota Press, 2008).

If you would like some hands-on experience with postmodern theory, you would do well to consult an excellent series: *Case Studies in Contemporary Criticism* (New York: St. Martin's Press, 1993–). After reprinting a classic text, the editor offers five analyses of that text, each of which represents a given contemporary school (feminism, Marxism, deconstruction, etc.). Furthermore, each essay is preceded by a succinct overview of the theories, approaches, and methods of the theoretical school represented by that essay and by a very useful, up-to-date bibliography of key books and articles related to that school. I would suggest *Frankenstein*, 2nd edition (2000); *Wuthering Heights*, 2nd edition (2003), *Hamlet* (1993), and *Great Expectations* (1995).

If you would like to read more traditional, canonical-friendly, Christian-friendly critiques of classic works of literature, I would highly recommend *Ignatius Critical Editions* (San Francisco: Ignatius Press). In 2008, they published editions of *Frankenstein*, *Wuthering Heights*, *King Lear*, and *Pride and Prejudice*. Editions of *The Scarlet Letter*, *Hamlet*, *Uncle Tom's Cabin*, and *Huckleberry Finn* followed in 2009, with the promise of many more to follow (including editions devoted to metaphysical poetry and Romantic poetry).

Much of what I cover in chapter 4 is discussed in much greater detail

in a twenty-four-lecture series that I produced with The Teaching Company (http://www.teach12.com), *Plato to Postmodernism: Understanding the Essence of Literature and the Role of the Author*. The series also includes a course guide in which I offer an extensive annotated bibliography and cross-listed glossary of literary terms. In my understanding of literary theory I have been much influenced by the fourfold system laid down in chapter 1 of M. H. Abrams's *The Mirror and the Lamp: Romantic Theory and the Critical Tradition* (Oxford: Oxford University Press, 1971). In addition to offering a brief history of Western literary theory, Abrams offers a richly detailed study of the sources, assumptions, and legacies of the Romantic theorists (both English and German).

Three books that will help you to view literature from exciting new perspectives and to think like a theorist without losing your passion for literature are C. S. Lewis's *An Experiment in Criticism* (Cambridge: Cambridge University Press, 1992), Cleanth Brooks's *The Well-Wrought Urn* (New York: Harvest, 1956), and Northrop Frye's *Anatomy of Criticism* (available currently only in a ridiculously expensive hardcover, but used paperbacks abound).

In chapter 5 of my *Lewis Agonistes*, I argue for an "aesthetics of incarnation" that can redeem postmodernism and deconstruction. Christian readers in search of a critic who combines a high view of Scripture as the Word of God with an appreciation of the literary devices used in the Bible are strongly encouraged to read Leland Ryken's *How to Read the Bible as Literature* (Grand Rapids, MI: Zondervan, 1985).

INDEX

+ CHECK OUT THE OTHER BOOKS IN THE
**RECLAIMING THE CHRISTIAN
INTELLECTUAL TRADITION SERIES**

THE GREAT
TRADITION OF
CHRISTIAN
THINKING
A STUDENT'S
GUIDE

David S. Dockery &
Timothy George

Now Available

THE LIBERAL
ARTS
A STUDENT'S
GUIDE

Gene C. Fant Jr.

Now Available

POLITICAL
THOUGHT
A STUDENT'S
GUIDE

Hunter Baker

July 2012

PHILOSOPHY
A STUDENT'S
GUIDE

David K. Naugle

September 2012